KEY

W9-DAY-875

T Trams

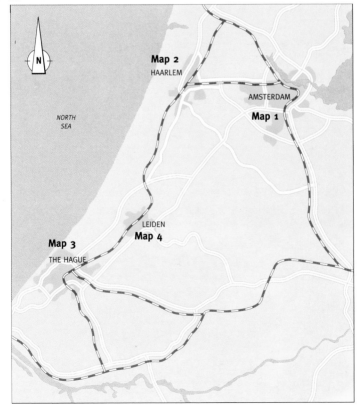

First North American Edition

ISBN 0-8212-2234-1

Library of Congress Catalog Card Number
95-76701

Bulfinch Press is an imprint and trademark
of Little, Brown and Company (Inc.)
Published simultaneously in Canada by
Little, Brown & Company (Canada) Limited

PRINTED IN SPAIN

ART IN *focus*

Amsterdam

AMSTERDAM
AND THE HAGUE

Christopher Wright

A Bulfinch Press Book
Little, Brown and Company
Boston • New York • Toronto • London

Contents

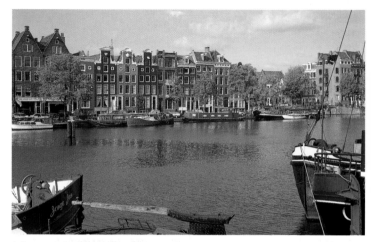

1. HOUSES ON THE AMSTEL RIVER

Were Rembrandt to return today he would still recognize most of the centre of Amsterdam, since few buildings rise above the seventeenth-century rooftop level. Amsterdam was and still is a commercial city run by burghers rather than nobles, with the consequence that there are no great palaces, castles and family art collections. Yet although it lacks these, and an obvious focal point such as a great cathedral, the city is almost entirely picturesque. There are few European cities that can make this claim because many rely all too frequently on great set pieces and grand buildings and monuments, leaving their more modest streets without charm.

Amsterdam's special place in the history of architecture is due to the fact that the small medieval centre was largely rebuilt in the seventeenth century based on a series of concentric canals, at which time its area was almost quadrupled, although it still remained on a human scale. Almost all the later development has taken place in the form of extensive nineteenth-century suburbs and vast twentieth-century housing estates even further out. The two largest and most obvious buildings in the city are the Rijksmuseum and the railway station, both built in the nineteenth century by the same architect, Kuypers. They are in the same hybrid Gothic-cum-Renaissance style with few concessions to Dutchness, and both contrive to perform their functions with some bravery, although at the time they were built they would have seemed almost interchangeable. Yet it is the overall effect of the streets rather than the individual buildings that gives the city its unique appeal, and it is for this reason that works of architecture are not featured in this guide as attractions in their own right.

Amsterdam was the boom town of the seventeenth century and not a place of commerce and splendour in medieval times like the rich cities of the southern Netherlands – Ypres, Ghent and Bruges. The enormous economic expansion of the sixteenth century which made Antwerp the

Amsterdam has been fortunate in its topographers. A good number of the outstanding works of art in these pages are views of Amsterdam, and many other collections throughout the Western world contain more pictures of this type, as they are not all automatically preserved in the city. The most prolific period of Amsterdam view painting was the seventeenth century, and what attracted painters then was not the picturesque. There were many more sights all over the Dutch Republic which were much more interesting. The medieval skyline of Utrecht, with its numerous towers and spires, was rarely depicted, and picturesque Delft was not often shown, although Vermeer's *View of Delft* (page 107) is an exception.

The explanation must lie in the prestige of Amsterdam in its time as the Manhattan of its day. Visitors marvelled at the visible wealth of the city, so it was natural than its topography should have been depicted irrespective of its picturesque potential. The focal point of the city in the seventeenth century became Dam Square, created by the demolition of the ruins of the old town hall and the building of the new one. This exposed the side of the late-medieval Nieuwe Kerk and it was this 'new' view which attracted painters as a novelty. Unlike Utrecht the church

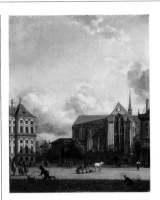

2. JAN VAN DER HEYDEN, *THE NIEUWE KERK*, c. 1670 (AMSTERDAM HISTORISCH MUSEUM)

lacked a tower and although one was planned and begun it was never finished. Jan van der Heyden's *The Nieuwe Kerk, Amsterdam* (2) has all the finesse and clarity which makes the artist's work so esteemed today.

Van der Heyden's career as a topographical painter went in parallel with his interest in fire-fighting techniques. The destruction of nearly ninety per cent of London in the great fire of 1666 was an example not lost on the Dutch, and even though largely built of brick, as a closely packed city Amsterdam was vulnerable to this hazard. The newly built canals themselves drew fewer painters (although Gerrit Berckheyde produced a memorable view, (8)); it was the older buildings to which most artists were attracted.

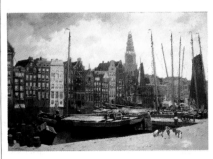

3. GEORGE HENDRICK BREITNER, *THE DAMRAK, AMSTERDAM*, c. 1900 (RIJKSMUSEUM, AMSTERDAM)

greatest port in Europe passed Amsterdam by; Leiden and Haarlem were both far larger in this period. Art in the city followed much the same pattern. There was some modest achievement in the sixteenth century, when Cornelis Anthonisz. (page 19), and the distinguished Antwerp painter Pieter Aertsen worked in Amsterdam for a time. The latter's pictures fell foul of the iconoclasts and now we have to make do with a large cow's head cut from a once splendid *Adoration of the Shepherds* in the Historisch Museum. In the early seventeenth century when Amsterdam began to grow there were a few painters active such as Pieter Lastman, who taught Rembrandt for a time, but Lastman's achievement cannot compare with that of the brilliant school of painters in Utrecht who came under the spell of Caravaggio.

It was only in the boom years of the seventeenth century that Amsterdam came into its own as a centre which attracted artists from elsewhere, rather than nurturing them as a local school. Jacob van Ruisdael (pages 48 and 102) transferred from nearby Haarlem in mid-career, Metsu (page 38) came from Leiden and changed his speciality from religious pieces to genre, Pieter de Hooch (pages 35 and 36) originally from Rotterdam, came to the city from Delft, and developed a more elegant way of working. Above all it was Rembrandt (pages 23, 44, 45, 46, 47, 99, 100 and 124) who came from Leiden, whose art became bound up inextricably with Amsterdam. Many painters had already achieved maturity when they had arrived, and because of their very inventiveness and lack of dependence on one another, there was no identifiable Amsterdam school, with the exception of those artists whom Rembrandt trained.

The history of Dutch art is well illustrated in the Rijksmuseum, which is by far the largest collection in the whole country. Yet the visitor has to pick his or her way through a complex maze of the history of collecting and attempt to make sense of the disparate elements. The Rijksmuseum's decorative arts are exemplary in their display if not in their comprehensiveness, although there are a limited number of individually outstanding objects. There are no displays of antiquities, for those are at Leiden, and for lovers of medieval art the Rijksmuseum Catharijnconvent at Utrecht is the place to go.

The paintings collection is not dominated by the presence of a great benefactor. A certain Van der Hoop amassed some distinguished seventeenth-century pictures including works by Pieter de Hooch and Vermeer and bequeathed them to the city of Amsterdam whence they were transferred to the Rijksmuseum in 1882. Yet there was no *eminence grise* like King Willem I who enriched the Mauritshuis in The Hague in the 1820s, providing Rembrandt's *Anatomy Lesson of Dr Tulp* (page 99), removed from Amsterdam to the pecuniary advantage of the Surgeons' Guild.

The focus of the collection is the work of Rembrandt, and it is his pictures which make the Rijksmuseum, and indeed the city, symbolic of the great achievement in painting of the Dutch golden age of the seventeenth century. A surprising number of them have been acquired in the last fifty years or so and the collection now is perhaps the best balanced of all Rembrandt's work. The Rijksmuseum contains some 5000 paintings as against the 2000 or so in the National Gallery in London. From these numbers not only does the museum have to select what is permanently exhibited, but the visitor too has to concentrate on some specific area. As in all

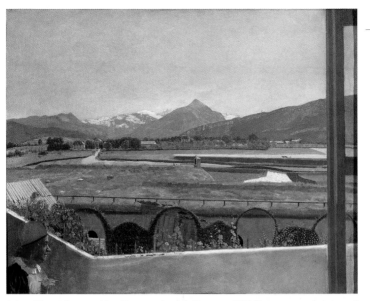

4. Jean Etienne Liotard, *View From the Artist's Studio*, c. 1780 (Rijksmuseum, Amsterdam)

great museums there are unexpected treasures and some of them are discussed here. There are wonderful works by Goya, Piero di Cosimo and Prud'hon (pages 30, 42 and 44) and the list could be extended. Not always exhibited owing to its fragility is a pastel by one of the greatest artists in this difficult medium, Jean Etienne Liotard – *View From the Artist's Studio Near Geneva* (4). Liotard's main work was as a portraitist and only later in life did he turn to other subjects, a few still life pictures and this scintillating view, which appears to be completely naturalistic.

The collection of seventeenth-century paintings is rich indeed but not with the unusual. The pictures are well-spaced and hung in a good and even light which makes them easy to appreciate. The lack of the offbeat is made up for by the high quality of the individual examples. Certain things are lacking. There are few good examples of the work of Aelbert Cuyp, the cow and landscape painter, outside his native Dordrecht. Some of Cuyp's pictures veer towards the Italianate, as does an example in the Rijksmuseum, and these Italian views were long out of fashion as they were considered to be un-Dutch. One of the best examples of this under-appreciated genre is Jan Asselijn's *Waterside Ruins in Italy* (5) which is such a contrast to his *Threatened Swan* (page 25). Asselijn understood almost better than any of the other Italianate landscapists the subtle golden light of the Italian scene.

The realistic landscape tradition, on the other hand, is rather better represented, especially with Van Goyen (page 31) and Jacob van Ruisdael. Ruisdael's *View of Haarlem From the Northwest* (6) is a contrast to the *Mill at Wijk bij Duurstede* (page 48) and shows how he was able to reinterpret the same theme. In his colour he achieved a perfect naturalism especially with the sooty blackness of the clouds, contrasted with the patches of blue sky. Above all Ruisdael's pictures of this type have a superb sense of space and air, which still can be felt in the Dutch countryside.

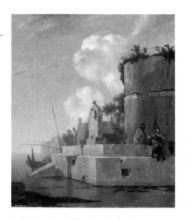

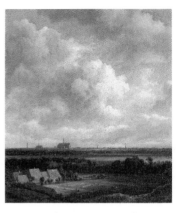

5. Jan Asselijn, *Waterside Ruin in Italy*, c. 1640 (Rijksmuseum, Amsterdam)

6. Jacob van Ruisdael, *View of Haarlem*, c. 1670 (Rijksmuseum, Amsterdam)

Topography was also one of the passions of the Dutch seventeenth-century painters, a tradition which lingered on. One of the best and most touching of these pictures is Saenredam's *Old Town Hall, Amsterdam* (7). This building was scheduled to be demolished on the completion of the large New Town Hall which is seen obliquely in Jan van der Heyden's *View of the Dam Square* and in the nineteenth century work by Breitner (page 63). Before the Old Town Hall could be demolished it burned down and Rembrandt drew the ruins after the fire. Saenredam made his wonderfully accurate view of the ramshackle medieval building with all its additions, accretions and municipal notices. It emphasizes the relative poverty of Amsterdam, especially when compared to the magnificent municipal buildings erected in the fifteenth and sixteenth centuries in Bruges, Ghent, Antwerp and Brussels. Sometimes a topographical picture is doubly informative because it allows us to compare with the scene of the present day. Gerrit Berckheyde's *The Bend in the Herengracht near the Nieuwe Spiegelstraat* (8) shows exactly how the canals looked before the trees had grown up, and can be compared with Isaak Ouwater's eighteenth-century view (page 21) for an idea of transformation that took place over the following century.

Another strand in Dutch seventeenth-century painting associated with Utrecht was the influence of Caravaggio. The Rijksmuseum has a few examples by leading painters, especially ter Brugghen. One of the least expected is Christian Jansz. Dusart's *Young Man by Candlelight* (9) which shows the Dutch preoccupation with night scenes (see also Judith Leyster, page 95). It also shows how in the seventeenth century many of the hundreds of minor painters were occasionally capable of producing small masterpieces even if the bulk of their work was more run of the mill.

7. Pieter Jansz. Saenredam, *The Old Town Hall, Amsterdam*, 1657 (Rijksmuseum, Amsterdam)

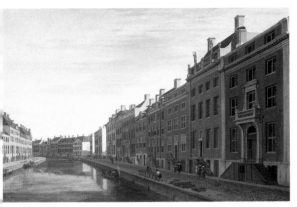

8. GERRIT BERCKHEYDE, *THE HEREN GRACHT NEAR THE NIEUWE SPIEGELSTRAAT*,
1672 (RIJKSMUSEUM, AMSTERDAM)

One of the sub-sections of the main genres is the winter scene, which was taken over from the sixteenth-century Flemish tradition. Perhaps the best artist in this genre was the earliest, Hendrick Avercamp, whose *Winter Landscape with Skaters* (10) parallels the one in The Hague (page 87), showing the consistency of the artist's achievement. The most prolific of the mid-century winter scene painters was Aert van der Neer, and the Rijksmuseum has several examples of his work.

Still life for some reason, although admired, has often been one of the less popular aspects of Dutch seventeenth-century painting. It may also come as a surprise to note that the holdings of still life and flower pieces in all the Dutch museums is relatively limited. Some of the most opulent are by Abraham van Beyeren, whose *Banquet Piece* (11) is an example of the type which has become more popular in recent times. Even so the more austere breakfast pieces of the Haarlem painter Pieter Claesz. are often preferred.

The classification of Dutch seventeenth-century art by subject matter has the effect of making it easier to understand for the layman, but the truly great artists of the period tend to defy this easy categorization. Rembrandt is certainly one of them. His *Self-Portrait as the Apostle Paul* (12) is part of a sequence of self-portraits and at the same time one of the artist's limited number of religious pictures. How a Dutch burgher of the 1660s could have taken to a picture of Rembrandt dressed up as a saint we will never know, but the bizarre combination serves to emphasize the complexity and ambiguity of Rembrandt's approach.

Some of the most highly praised paintings in the Rijksmuseum are those by Jan Vermeer of Delft (three of the four works in the collection are shown on pages 52, 53 and 54). The fourth, Vermeer's *Love Letter* (13), is not the easiest to appreciate of the artist's paintings. It is too intense and at the same time too vulgar in

9. CHRISTIAN JANSZ. DUSART, *YOUNG MAN BY CANDLELIGHT*, 1645 (RIJKSMUSEUM, AMSTERDAM)

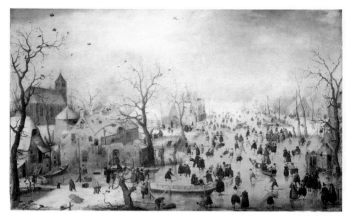

10. Hendrick Avercamp, *Winter Landscape with Skaters*, c. 1620 (Rijksmuseum, Amsterdam)

sentiment compared to the exquisite simplicity of *The Maidservant Pouring Milk*. The mistress of the house has received a love letter and the maid's knowing look suggests that all is not well. The picture astonishes by the brilliance of the colour in the room intensified by the dark shadows.

These Vermeers, all of them small, inevitably lead visitors to ask where the *View of Delft* is to be found. They might also wonder about Frans Hals, who is only modestly represented. There is only one work by Hobbema and no pictures at all by the great fifteenth-century Netherlandish masters, Memlinc and Van der Weyden in the Rijksmuseum. This lack has led to the inclusion in this guide of the easily accessible major collections in the nearby Dutch cities, leaving out Rotterdam which is a full hour's journey from Amsterdam, and Utrecht, whose extensive collections are of a more specialist interest.

Haarlem, the home of Frans Hals, is a few minutes train journey away and offers the greatest possible contrast with Amsterdam. It is a sleepy place with a slight feeling of remoteness. There are few concessions to the twentieth century and the whole town is dominated from every angle by the

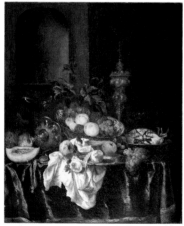

medieval church of St. Bavo, which stands in the old centre. Haarlem's main collection in the Frans Hals Museum (page 73) concentrates entirely on Haarlem painters from the sixteenth to the eighteenth centuries. The Hals group portraits, especially the early ones from the 1620s, seem incredibly restless in their liveliness, but the late ones (page 77) have a gravitas unparalleled in seventeenth-century painting. In its serenity and its logical display of the development of a distinguished school of painting, the collection offers no surprises, but it has often been considered one of the most satisfying of collections.

11. Abraham van Beyeren, *Banquet Piece*, c. 1660 (Rijksmuseum, Amsterdam)

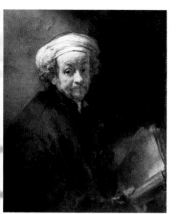

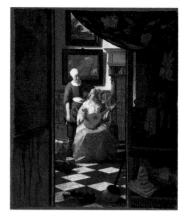

12. Rembrandt, *Self-Portrait as the Apostle Paul*, 1661 (Rijksmuseum, Amsterdam)

13. Jan Vermeer, *The Love Letter*, c. 1665 (Rijksmuseum, Amsterdam)

The other museum, The Teyler, surprises the unwary with Michelangelo drawings (see pages 79 and 80).

Some ten minutes before reaching The Hague on the train a stop is always made at Leiden coming from either Amsterdam or Haarlem. Everybody knows that Leiden is where Rembrandt was born, and it has the added distinction of being the home of the most illustrious university. The museum collection has never been famous because it only contains one early work by Rembrandt and only modest examples by the well-known Leiden masters such as Dou and Metsu, who are much better represented in the Rijksmuseum in Amsterdam. But it is for the sixteenth-century pictures – all of them in one unforgettable room – that the pilgrimage is made to the town.

The Hague, federal capital since the late sixteenth century and meeting place of the States General, is a confusing and disconcerting city, cut up by motorways and surrounded by vast suburbs, with a small and incoherent historic centre. The Mauritshuis itself, a star attraction for art connoisseurs the world over, has often been cited as the foremost small museum of Western art, although this must depend on the visitor's preferences. The quality of Dutch seventeenth-century art is exceptional, and for the other European schools there are isolated masterpieces by artists such as Holbein, Rubens (page 101) and Van der Weyden (page 109). Amongst the few pictures to survive from the historic collection of the Mauritshuis are the series of portraits of members of the Orange family. Yet there are no paintings in the Mauritshuis of the main events of Dutch history, and those in search of pictures showing the history and topography of the Hague should go to the Haags Historisch Museum (page 81). The major artists were not generally interested in the seventeenth-century deliberations of the States General with their endless discussions of financial matters.

From an artistic point of view the Hague is the exact opposite of Amsterdam, where there is an overriding concentration on the Rijksmuseum. Apart from the Mauritshuis, a good number of individual collections survive in separate institutions. The city authorities run the major Gemeentemuseum which concentrates on twentieth-century art (page 83) and the newly created Haags Historisch Museum. The three other collections – Mesdag (page 113), Bredius (page 110), and

Group portraits dominate Dutch public collections in way found in no other European country. Although they are generally regarded as somewhat academic, some of the most famous images in the whole of Dutch art are group portraits, for example Rembrandt's *Night Watch* (page 46) and the dazzling sequence by Frans Hals at the museum in Haarlem (see page 77).

Far from being dreary line-ups of long-forgotten functionaries these great pictures, especially the sequence in the Historisch Museum in Amsterdam, offer a unique insight into the social history of the time. The Dutch had a highly developed sense of social necessity, and felt that things went better if they were regulated by committees and boards. Many charitable institutions such as orphanages were founded and very carefully administered. A painting by one of Rembrandt's pupils entitled *Clothing the Children in the Diaconnieuweeshuis, Amsterdam* (14), offers a clear insight into the way these charities were administered.

The origins of the group portrait are obscure. Other countries had confraternities, militia companies, orphanages, governors and committees, but only in the Netherlands did it become a regular custom for these people to be painted as a collective record. The earliest ones to survive tend to show a simple but well-observed line of figures – Jan van Scorel's *Knightly Brotherhood* at Haarlem (page 74) is one example – and only later in the sixteenth century did the group portrait proper develop as an arranged composition. As painters' talents diversified, the strictly factual approach gradually gave way to the depiction of some form of action. It reached its extreme in Rembrandt's *Night Watch*, where the wayward artist departed so much from the recording aspect of the commission that he incurred the displeasure of his patrons.

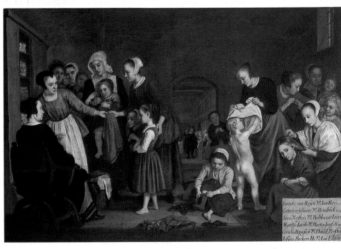

14. JAN VICTORS, *CLOTHING THE CHILDREN IN THE DIACONNIEUWEESHUIS, AMSTERDAM*, c. 1660 (AMSTERDAM HISTORISCH MUSEUM)

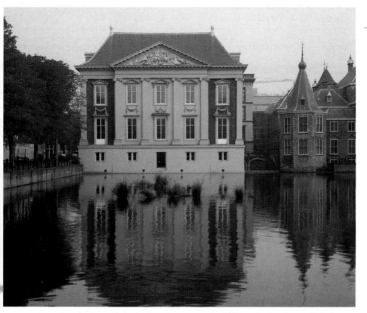

15. The Mauritshuis, The Hague

Meermanno-Westreenianum (page 117) are not to everyone's taste, but taken collectively they cover a remarkably wide range of art from the Italian fourteenth century to the French nineteenth.

Taken as a whole, these Dutch collections are remarkably extensive in the context of the small size of the country and its population. Several extremely distinguished collections are outside the scope of this guide because they are not within easy reach of Amsterdam and require a planned excursion rather than a spur-of-the-moment decision to make a visit. For the nineteenth and twentieth century, the most spectacular is the Rijksmuseum Kröller-Müller at Otterlo out in the countryside in the direction of Arnhem. Rotterdam, already mentioned, certainly has the best-balanced of all Dutch collections because, apart from its Dutch holdings, it houses fine Italian, Flemish, and French paintings of most centuries.

Dutch museums on the whole tend to present their holdings in a matter-of-fact way. Few have period settings or 'country house' atmospheres (although the Schilderijenzaal Prins Willem V in the Hague, page 119, is an exception), and neither is there the late twentieth-century magnificence which dominates the new wings of the great museums in the USA. The level of information is also patchy. Most museums have some form of guide and the Rijksmuseum in Amsterdam, the Lakenhal Museum in Leiden, and the Mauritshuis in The Hague have weighty volumes which illustrate all their holdings in small black and white plates. The collections do not follow the now fashionable English and American habit of providing long explanatory labels, which would be mostly in Dutch in any case, so the visitor is usually expected to arrive armed with some form of prepared information. Dutch pictures are on the whole much smaller than their Flemish, French and Italian counterparts. Rather than impressing by their splendour they repay close inspection and patient attention to detail.

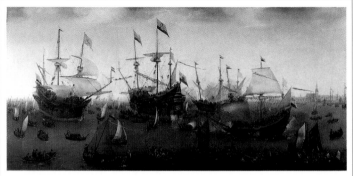

16. HENDRICK CORNELISZ. VROOM, *RETURN TO AMSTERDAM OF THE SECOND EXPEDITION TO THE EAST INDIES*, 1599 (AMSTERDAM HISTORISCH MUSEUM)

The Dutch preoccupation with the sea is well known, but this is not always reflected in the great Dutch art collections. The most distinguished and prolific sea painter, Willem van de Velde II, spent the second half of his long career working for the English with the obvious result that half his output remains in British collections. Another reason for the national dearth of marine art is that in later times seascapes, instead of being viewed as purely utilitarian, came to be seen as art and therefore a saleable commodity. The Dutch were such good salesmen in the eighteenth and early nineteenth centuries that they managed to part with some ninety per cent of their seventeenth-century patrimony, and the proportion of lost seascapes may be even higher

The visitor therefore has to be contented with the odd picture scattered through various collections. Only the Scheepvaart Museum has a modest survey of the main figures of the period, although the Rijksmuseum and the Mauritshuis have good examples by Jan van de Cappelle and Willem van de Velde II, painters whose approach was as artistic as it was nautical. The Historisch Museum in Amsterdam is fortunate to possess Hendrick Cornelisz. Vroom's *Return to Amsterdam of the Second Expedition to the East Indies*. Splendid ships dominate the composition, painted with pride as a record of commercial and colonial achievement.

The seventeenth-century masters have always been the most highly esteemed, and they were the founders of an astonishing tradition of sea painting which has continued down to the present day. Marine art, usually seen as a specialist sideline, has been an important branch of English and Dutch painting over the last three centuries. Almost all this vast output is based on the seventeenth-century tradition, and there has been little innovation in the basic format.

ART

IN

FOCUS

Museums

Paintings

Applied Arts

Architecture

Address
Kalverstraat 92, Amsterdam
℡ 523 1822

Map reference
①

How to get there
Centre of city, near the Dam
Square

Opening times
Mon to Fri 10–5; Sat and
Sun 11–5

Entrance fee
G. 7.50 adults; G. 3. 75
children under 16

The Amsterdam Historical Museum was one of the first of its type and remains one of the best. The idea was to arrange the miscellaneous objects ranging from archaeological finds to modern prints and posters so that they told a historical story, rather than to exhibit the objects in categories of their own. The result is far better than in many similar institutions, for instance those in London and Paris, because of the visual wealth of the collection. The history lover will find it one of the most satisfying of all museums of its kind.

The Dutch passion for painting most, but not quite all, of the aspects of their lives, both public and private, is seen pretty well. The high artistic quality of much of this material is all too easily overlooked because of the delight in the subject matter as an end in itself. Canal views, street scenes, a magnificent series of group portraits, dykes bursting, timber wharves and a host of other subjects, constantly intrigue. The later history of the city is not neglected as there are some spectacular pictures from the eighteenth century including Cornelis Troost's macabre *Anatomy Lesson of Dr Willem Roëll* of 1728. There are also numerous nineteenth- and early twentieth-century views of the city in different stages of reconstruction, some showing the muddle caused by the laying of tram lines. There are also dramatic events such as the entry of Napoleon into the city in 1811. The story continues to the present day although for modern times it has to rely on the camera. There is a particularly moving series of photographs showing the sufferings of World War Two. The collection has recently been enhanced by the transfer from the Rijksmuseum of Rembrandt's fragmentary *Anatomy Lesson of Dr Deijman*. This picture has often been compared with the masterpieces of the Renaissance owing to the foreshortened position of the partly dissected corpse, which resembles Mantegna's *Dead Christ* (in the Brera, Milan).

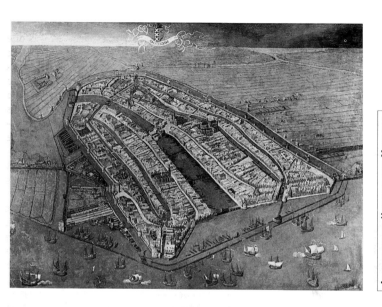

The city of Amsterdam has always owned this astonishing picture. It is a unique survival from the sixteenth century, even though such bird's-eye views were often used by cartographers, and the view is so accurate that the present-day layout of Amsterdam can be superimposed on it. The ships in the foreground occupy the present site of the railway station built on reclaimed land. The large waterway at the centre of the picture is now filled in and is the main street, the Damrak. The two large buildings to the right of the waterway are identifiable as the old Town Hall (painted by Saenredam, see page 10) which stood on the site of the Dam Square, and the medieval Nieuwe Kerk, which now occupies one whole side of the square. On the other side of the water the ancient Oude Kerk is easily recognizable, although nowadays it is rather hemmed in by surrounding buildings. Medieval Amsterdam was a relatively small place compared to the larger and richer Dutch towns of Haarlem, Leiden and Delft.

Very little is known about the artist Cornelis Anthonisz. (c. 1500/07–61), but he was responsible for a number of group portraits of Amsterdam guilds which still survive. His career was spent in Amsterdam and he was one of the few artists of consequence working there in the sixteenth century; there was a richer painting tradition in Leiden at the time.

The Anatomy Lesson of Dr Sebastiaen Egbertsz. de Vrij

1619

Nicolaes Eliasz. called Pickenoy

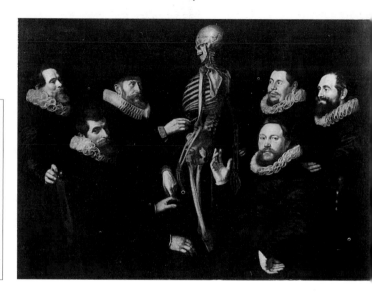

Nicolaes Eliasz. (1590/1–1654/6) was the leading portrait painter in Amsterdam before the arrival of Rembrandt in 1632, and this rather archaic work shows the type current in the city before the approach was revolutionized by Rembrandt (see *The Anatomy Lesson of Dr Tulp*, page 99). The learned doctor, to the left of the skeleton, is lecturing on human anatomy to a group of younger men. As the Rembrandt picture also shows, the lecture would have been given in public, so the painting does not record the type of intimate event that would have taken place in medical schools in later times. It is clear from the careful but lively depictions of each sitter that the artist's local reputation was deserved. The facial expressions are individual, and each sitter would have had to pay for his own portrait. The picture is also evidence of the Dutch interest in scientific enquiry on an empirical basis; in this they were far ahead of most other European countries. Until very recently the painting was thought to be by the better-known Thomas de Keyser, but this is hardly possible as the doctor died in 1621, some time before de Keyser began his career.

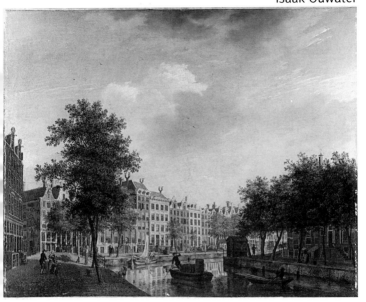

AMSTERDAM: HISTORISCH MUSEUM

By the time this picture was painted in 1783 trees had grown up alongside the canals of Amsterdam, especially the ones newly laid out in the boom years of the seventeenth century, and they had thus acquired the familiar leafy charm which makes them so attractive to present-day visitors. The painter Isaak Ouwater (1750–93) unfortunately remains little known outside the Netherlands even though he was one of the best Dutch painters of his time. His work, in spite of the esteem in which it has always been held by the Dutch, has never been exported, and this is perhaps some explanation for the artist's strictly local reputation. He recorded scenes with relentless accuracy in clear, cool colours, but his technique was less polished than that of his seventeenth-century predecessors in townscape, and he was never able to achieve the atmospheric unity of Jan van der Heyden.

This picture seems more like a photograph, where the lens records without selecting. It is a visual puzzle to note the slight changes which have taken place from the previous century in the appearance of things; a strange new type of chimney cowl has been introduced and there is a little more street furniture. The Dutch obsession with neatness continues as we see a woman sweeping the paving stones on the right. There is an uneasy sense of order about the whole scene, from the uncurtained windows to the carefully pruned trees.

Address
Jodenbreestraat 4–6,
Amsterdam
℡ 624 9486

Map reference
②

How to get there
City centre

Opening times
Mon to Sat 10–5; Sun and
public holidays 1–5. Closed
1 January

Entrance fee
G. 7.50 adults; children
10–15 G. 5; children under
10 free

Rembrandt died in relative poverty, an undischarged bankrupt with his affairs managed by his son Titus and his daughter-in-law. It must therefore come as no surprise to find that there are no paintings by the master in the house which he was forced to leave through bankruptcy in mid-career. The building was in any case largely reconstructed in 1908–11. The rooms were put back as far as possible to how they might have been in Rembrandt's lifetime, but their neat arrangement bears no resemblance to the incredible clutter with which Rembrandt is known to have surrounded himself.

To compensate for this inevitable lack, the Rembrandthuis contains a virtually complete set of Rembrandt's etchings brought together from various sources. In most other European collections such a large number of etchings is not normally on view, even though Rembrandt's achievement in this field is generally held to be unsurpassed both in skill and variety of invention. He used the etching technique in an expressive way and this is especially obvious in the changes of mind which took place as the plate progressed. The museum has also acquired a small number of Rembrandt's drawings, including the well-known but rather faded one of himself (page 24). There is also Rembrandt's drawing of the ruin of the old town hall of Amsterdam after the fire of 1652, which makes a poignant contrast to the loving record of Saenredam in the Rijksmuseum (page 10).

There are also two paintings by Rembrandt's first master in Amsterdam, Pieter Lastman, which clearly show how Rembrandt soon progressed away from his master's bold but laboured style. In order to fill out the collection, a small number of pictures by Rembrandt's minor contemporaries and pupils have been placed on loan from various sources.

Rembrandt's (1606–69) drawings have always been recognized as among the supreme achievements of draughtsmanship, but they occupy an ambivalent position in his art between the paintings and the etchings. More than a thousand exist, but very few of them were made in preparation for either his paintings or his etchings. This is proof enough that he used drawing for its own ends unlike the great draughtsmen of the Italian Renaissance, who nearly always drew in direct preparation for a painted work; Michelangelo's drawing in the Teyler Museum, Haarlem (page 81) is one example.

Even though more than forty painted self-portraits by Rembrandt survive (see page 100), this drawing is unrelated to any of them. It exists as a rapid piece of self-observation in brown ink on paper with some wash. The blurred part at the belt is where excess ink has been erased, probably by Rembrandt himself. The drawing is remarkable in Rembrandt's usual way, particularly in its use of a few apparently unrelated lines to create a feeling of space and movement. The most delicate lines make the artist's smock appear to hang as a textile, and the face staring straight at the spectator has all the seriousness which we find in the painted self-portraits. The inscriptions on the drawing were almost certainly added later; Rembrandt was never one to explain.

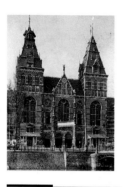

Address
Stadhouderskade 42,
Amsterdam
✆ 673 2121

Map reference
③

How to get there
On the southern edge of the
old city centre

Opening times
Tue to Sat 10–5. Sun and
public holidays 1–5. Closed
Mon and 1 Jan

Entrance fee
G. 12.50 adults; G. 10
groups over 20; G. 5
children 6–18; G. 4 groups
over 20 of children

In common with so many of the great art collections of Europe, the Rijksmuseum has in recent years been in a constant state of flux caused by much-needed reorganization and by the ambitious programme of large temporary exhibitions which occupy or cause disruption in the main galleries. The paintings are hung by century, and this means that the section devoted to the Dutch seventeenth century tends to overshadow the excellent holdings of sixteenth-century Netherlandish art and also the more modest areas of the Italian and French schools.

Rembrandt and Vermeer are supremely represented in the Rijksmuseum and there are examples of most of the thousand or so Dutch painters active in the seventeenth century. As a result the Rijksmuseum is a collection of remarkable evenness, and the contrast with the other great collections of Dutch seventeenth-century art could not be greater. There is usually in these other collections an over-balance of one type of art or specific pictures. The Hermitage in St. Petersburg has, for instance, over twenty Rembrandts – more than the Rijksmuseum – but no work by Vermeer. The National Gallery in London is better balanced but has only one group portrait.

The very centre of the Rijksmuseum is Rembrandt's *Night Watch* (page 46), now rehung in the position designed for it in the nineteenth century at the end of a long gallery of little cabinets for the lesser Dutch masters. The visitor is therefore tempted towards it rather than taking the longer journey through the rooms devoted to earlier painting. In this area there are one or two painful gaps, especially Hieronymus Bosch. Dutch Mannerism is well represented and the early development of the Dutch School around 1600 can be studied in detail in the delightful flower pieces and landscapes. As in all great museums, there is room for the unexpected, as is found in works by Goya (page 31) and Piero di Cosimo (page 43).

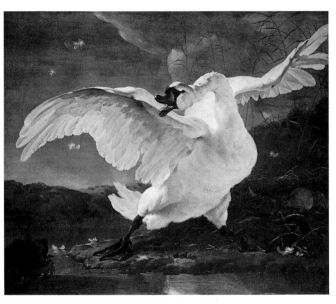

This is perhaps the best known and certainly one of the most successful paintings of a bird. It is all the more remarkable that it was painted by Jan Asselijn (1610 or later – 1652) who was a landscape specialist, and that it is his only known painting of this type. In the nineteenth century in particular this picture became famous in Holland as it was thought to be an allegory of the bravery of the Dutch seventeenth-century republic against Spanish aggression. It was not realized at the time that the inscription on the painting was added much later than the artist's lifetime.

The picture is best seen as an accurate piece of observation as swans are notoriously aggressive, especially when their eggs or young are threatened. It is easy to forget that there was little sentimentality about the animal kingdom in the seventeenth century, the only real interest being in the exotic (although Paulus Potter's depiction of a bull on page 98 is an exception). This makes the dramatic treatment of the bird all the more remarkable. Asselijn's delight in landscape is seen in the hilly background, which is reminiscent of Italy where he had spent the early part of his career. The composition – unusually for a Dutch artist – can be described as Baroque. The elaborately arranged system of flowing lines is made all the more startling by the low viewpoint and the drama is further increased by the large scale, as the swan is over life-size.

Helena van der Schalcke

c.1650

Gerard ter Borch

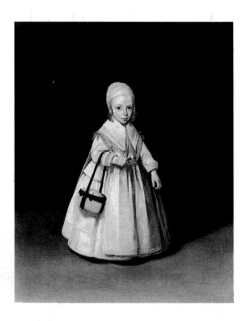

The sitter Helena van der Schalke (1646–71), shown here as a little girl, was the daughter of a Haarlem cloth merchant. He also was painted by ter Borch (1617–81) along with his wife, and these two pictures are also in the Rijksmuseum. Helena only lived to the age of twenty-five, and there is a portrait by Job Berckheyde of her husband, another Haarlem merchant, in the Rijksmuseum. This little picture, which seems conceived on such a monumental scale, symbolizes the Dutch need for an austere self-image. The Dutch were surrounded by both opulence and symbols of wealth (see the banquet piece by van Beyeren in the Mauritshuis, The Hague, page 88) but their Calvinist or Lutheran religion prevented them from indulging in personal adornment. Ter Borch usually took this austere sense one stage further and eliminated background detail, giving little indication of the status of his sitters. The sense of isolation and loneliness of the child as we see it now must not be overemphasized as this is a modern interpretation and not the artist's intention. Alone amongst the Dutch portraitists of the seventeenth century, ter Borch could reduce portraiture to its essentials. He was even able to forego his delight in texture, which is seen so brilliantly in such genre pieces as *Woman Writing a Letter* in The Mauritshuis, The Hague (page 89).

The Home Fleet Saluting the State Barge

1650

Jan van de Cappelle

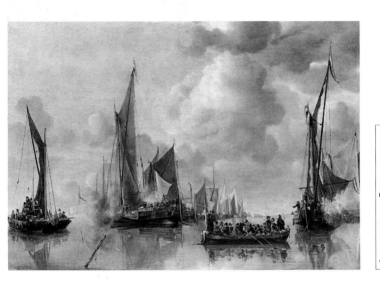

A great many Dutch sea pieces are purely imaginary. Patrons and collectors liked depictions of ships in calm or stormy water and they delighted in the different kinds of vessels, usually depicted with great accuracy, but were less interested in specific marine events. Jan van de Cappelle (1626–79), a seascape specialist, mostly falls into the category of a painter of imaginary scenes, and a specific event is a rarity in his work. In this picture the Prince Frederik Hendrik and the future Stadhouder Willem II are seen in the foreground in the official barge of the States General, which was the federal government in The Hague comprising representatives of all seven Dutch provinces. The fleet is shown firing a salute in honour of the dignitaries in the barge.

Jan van de Cappelle was one of the few Dutch seascapists whose interest lay in atmosphere and composition rather than accurate nautical observation. He was preoccupied with the balance of the ships' silhouettes seen against cloudy skies and enjoyed the semi-translucency of the ships' sails, open or partly furled. He was less good at figures and the boat full of them here does not repay close inspection. The artist had another career as the owner of a dye works and was also a major collector of the work of his contemporaries, especially drawings by Jan van Goyen and, more adventurously, those by Rembrandt.

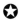

⭐ Rembrandt's Mother (?) Reading

c.1635

Gerrit Dou

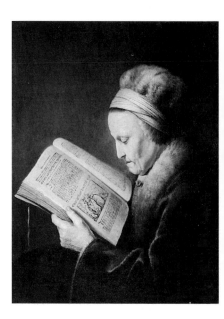

The traditional title for this popular picture is the appealing *Rembrandt's Mother Reading the Bible*. Sadly for the romantics it is probably inaccurate. Rembrandt's real mother, Neeltgen Willemsdr. van Zuijdtbroeck (died 1640), was not in extreme old age when this was painted, and the very old woman here is reading a lectionary, not the Bible. The only connection with Rembrandt is the fact that the artist, Gerrit Dou (1613–75), was for a short time his pupil and colleague in their early years in Leiden in the 1620s.

Most of Dou's pictures are on a very small scale, and he acquired a national reputation for his meticulous work: his obsession with dust in the studio was well known. His pictures almost always fetched higher prices than those of Rembrandt and it is only in modern times that the position has been reversed.

While it is easy to see what the subject of the picture is not, its real meaning remains unclear. It falls broadly into the category of genre with religious overtones, as the lectionary deals with those portions of the scriptures appointed for divine service. It is likely that such pictures did not have a strictly devotional intent but were to serve as reminders of religious instruction. After all, to own such an elaborate work by Dou would have been the privilege of the well-off. Unlike Rembrandt, Dou hardly changed his style throughout his long career, and his painstaking way of working meant that his output remained small.

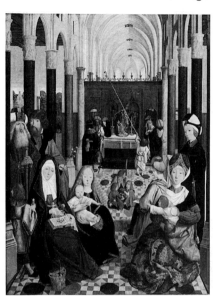

AMSTERDAM: RIJKSMUSEUM

Of all the late fifteenth-century pictures painted in the northern Netherlands, this is one of the most beautiful and most controversial. It has often been attributed to Geertgen tot Sint Jans (*c.* 1460/5–*c.* 1488/93) whose short career probably, but not certainly, took place in either Haarlem or Leiden. The pictures traditionally associated with Geertgen's name are highly eccentric, especially in the treatment of facial expression. *The Holy Kinship* has this quirky character with the eyes rendered as dark coal-like spots, and odd gestures. The painting's northern character is obvious in the lack of supreme skill in the treatment of the draperies and architecture that is characteristic of paintings produced in the southern Netherlands by artists such as Hans Memlinc (page 96) or Rogier van der Weyden (page 109). Instead of refinement there is a robust and individual approach, and even the subject matter is a little offbeat. Christ's family is shown out of scale in a splendid Gothic church convincingly rendered in every detail. The failure to relate the scale of the figures to their setting is deeply disconcerting. St. Elisabeth on the right is stylishly dressed in contemporary rather than religious attire and great play is made of the brocade of her dress and her extravagant headgear. On the other side St. Anne, the mother of the Virgin, has nodded off leaving her spectacles on the open book. Even the Virgin, less dominant than might be expected, appears sleepy. What makes the picture exceptional is the exquisite sense of calm amidst all the elaboration.

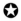
1823

Francisco de Goya

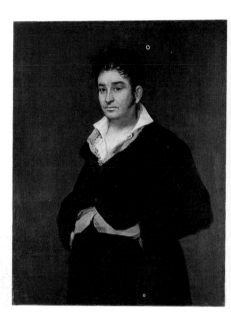

Painted at the end of his long life, this is one of Goya's (1746–1828) most subtle portraits, devoid of the savage observation seen in the royal portraits he painted for the Spanish court in the early part of the century. The sitter (1765–1825) was a judge of the Fifth Chamber of the Council of Castile, but the artist has made him look remarkably young for a man of fifty-eight. Goya was steeped in the eighteenth-century tradition of portraiture, but this work is remarkably up-to-date for an old man – he was seventy-seven when he painted it. Although the sitter had a senior position in the legal profession he is shown in a casual pose, with his shirt undone and his hair in the fashionably dishevelled style more typical of Byronic romanticism than legal portraiture. In general treatment, however, Goya has continued the Spanish tradition of austerity seen at its best in the portraits by Velázquez in the seventeenth century. The only innovation is the bright red waistcoat which appears above and below the black jacket. Even the background is kept absolutely plain .

The fact that this is the solitary Spanish masterpiece in the Rijksmuseum might indicate the survival of prejudice against things Spanish going back to the struggle for independence in the seventeenth century. The Dutch have never collected Spanish art and this picture was a brave purchase by the museum from Duveen in New York in 1922.

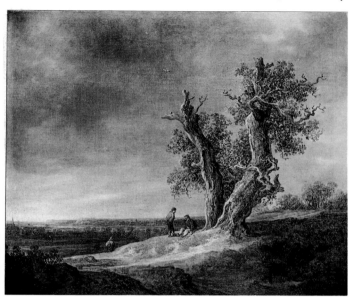

As might be expected of a pure landscapist preoccupied with light and atmosphere, Jan van Goyen (1596–1656) was not associated with Amsterdam where there was no real tradition of landscape painting, although his work was avidly collected by the seascape artist Jan van de Cappelle (page 27). In scale and breadth the *Landscape with Two Oaks* is much more ambitious than is usual for van Goyen, who often painted much smaller pictures. It is said that his rapid output of so many small-scale works – over a thousand survive – was because he had ruined himself speculating in tulip bulbs, and needed to be paid rapidly in order to recoup his losses.

Van Goyen's subtle rendering of grey atmosphere was not rediscovered until the late nineteenth century. The *Landscape with Two Oaks* is an especially good example of his skill; distance is suggested rather than painted in detail and the main motif, the two straggling oak trees, is handled with great freedom and delicacy. Even though Jan van Goyen had none of the monumental austerity of Jacob van Ruisdael, especially in the treatment of skies, his limited palette was perfectly suited to the painting of damp air. He understood nature's harmonies of greys and greens when the sky and the earth appear to reflect back upon each other. Figures play a very small part in the whole, and the artist was hardly ever interested in their facial expressions.

c.1630

Frans Hals

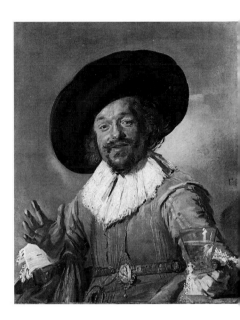

The jollity of this figure is usually taken to epitomize Hals's (1581/5–1666) work, when most of his portraits actually show rather stern sitters. This famous painting is the Rijksmuseum's answer to not having Hals's *Laughing Cavalier*, which to many people's surprise is to be found in the Wallace Collection, London. Hals's brilliance was in facial expression rather than in any great penetration of character, although the mood changed in the late group portraits at Haarlem (page 77). This picture is so freely painted that it is easy to see how the artist worked up the illusion of movement with repeated rapid brushstrokes and no emphasis on surface polish. All the soft elements such as the hair, moustache and beard are suggested with just a few brushstrokes. The same is true of the falling collar, and even in the painting of the drinker's glass the touches of the brush are so rapid that it looks as though the drinker is moving it slightly. Contrary to current academic thinking, this is likely to be a simple piece of observation rather than a warning against the evils of drink (unlike Jan Steen's *Merry Family*, page 50).

It is now possible to see why Hals was neglected for so long, especially in the eighteenth and early nineteenth centuries when highly finished pictures were so esteemed. His rediscovery in the late nineteenth century meant that he was greatly admired by artists as divergent as Manet and Sargent.

Portrait of a Woman
(formerly called Anna Codde)

1529

Maerten van Heemskerk

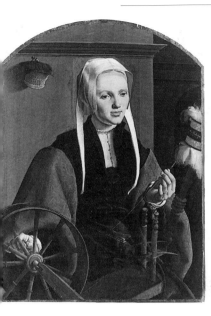

Maerten van Heemskerk (1498–1574) was the pupil of Jan van Scorel (page 74), himself an accomplished portraitist. Like Scorel, Heemskerk visited Italy, especially Rome, where he made a number of impressive drawings of the ruins of antiquity. His *Self-portrait* (Fitzwilliam Museum, Cambridge) even includes Rome's Colosseum in the background. Heemskerk's formal portrait style, however, was more conventional and he followed the same skilled and realistic tradition as his master Scorel. The sitter here is not known although she is likely to have been from the professional classes, as her husband, also shown in a painting by Heemskerk in the Rijksmuseum, is shown with an open book. It is unusual for a well-dressed woman of the period to be shown at the spinning wheel, especially as the painting is clearly a portrait. The picture's quality is obvious from the acute sense of line which is seen in every detail as well as in the face. This comes from a new awareness of the importance of drawing, which the artist learned during his Italian sojourn.

Portraits of this type were fashionable throughout the sixteenth century, as it remained usual to include some symbol of the sitter's profession, interests or status. The change in style to a much more anonymous approach only came about with the emergence of the Dutch Republic in the early seventeenth century.

⭐ The Celebration of the Peace of Münster, 18th June 1648

1648

Bartholomeus van der Helst

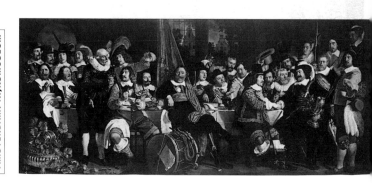

Many visitors to the Rijksmuseum are more impressed by this vast and brilliant canvas than they are by Rembrandt's sombre *Night Watch* (page 46), and so it was in the seventeenth century. Bartholomeus van der Helst (1613–70) took over from Nicolaes Eliasz. (page 20) in the 1630s as the leading portrait painter in Amsterdam and it was quite natural that such an important commission should go to him rather than to Rembrandt. The peace treaty itself was the symbolic end of the Dutch struggle against the Spanish. Ter Borch's small but detailed depiction of the signing of the treaty, painted from life, is in the National Gallery, London.

The celebration shown here is taking place in the headquarters of the Crossbowmen's Civic Guard in Amsterdam. With near genius van der Helst has managed to include all the sitters in a coherent design which is never out of focus despite its 547 cm length. The comparison with the *Night Watch* is inevitable because it was Rembrandt's inability to give each sitter equal emphasis which led to their displeasure. Van der Helst has managed to make the composition function but each likeness still convinces. There are touches of bright colour throughout the picture even though the central figure is in black. Van der Helst's reputation deserves to return to its seventeenth-century prominence especially on the strength of this *tour de force*.

Woman and Child in a Pantry

c.1658

Pieter de Hooch

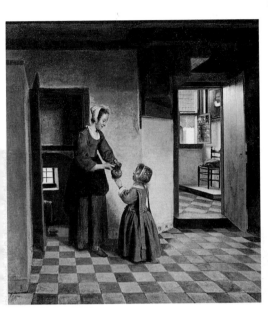

Pieter de Hooch's (1629–84) fame rests equally on his interiors and his courtyard scenes, and the Rijksmuseum is fortunate to have exceptional examples of both types of painting. There is always the temptation to compare his interiors with those of Vermeer, who was so much more interested in the fall of light and in the formality of composition. De Hooch, on the other hand, was often more sensitive than Vermeer to the trivial subtleties of daily life. As the woman hands the child the jug which she has just removed from the pantry her gaze is one of affection, the child's gesture is one of expectation, and the artist has grasped this relationship perfectly.

It is likely that the painter left the room so bare for artistic reasons; it gave him the opportunity to delight in the perspective of the tiled floor. Dutch so-called realism is almost always tempered by the need to the display great skill, and even Vermeer made numerous adjustments to what we know he would have seen in his *View of Delft*, (Mauritshuis, The Hague, page 107). In contrast to Vermeer, de Hooch has used relatively low tones and subtle hues that are quite different from the studied brilliance of his outdoor scenes. It is not known exactly when de Hooch left Delft for the glamour of Amsterdam, but it is likely that this picture was painted after his arrival in the city.

⭐ Three Women and a Man in a Courtyard Behind a House

c.1663–65

Pieter de Hooch

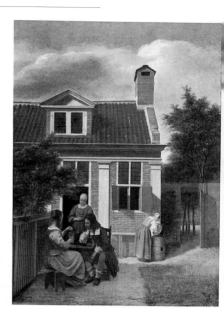

The contrast between the subtle tones of de Hooch's (1629–84) interior scenes and this bold outdoor work is dramatic. De Hooch was one of the few Dutch artists of his time to be able to handle the effect of bright sunlight. It is interesting to compare this picture with Vermeer's *The Little Street* (page 52), particularly for the depiction of the building. De Hooch's technique is meticulous and illusionistic at the same time, but there are fewer imperfections in the bricks than those recorded so artlessly by Vermeer.

As is expected with de Hooch there is a strong emphasis on the intimacy of the scene. A couple are seated close together but facing one another at a table; she is drinking, he is smoking, while the older woman with a large glass in her hand looks on smiling. There is no means of knowing whether this is an indelicate scene of temptation or a portrayal of a betrothed couple smiled on by a prospective in-law. In order to balance the composition and to emphasize the ordinariness of the scene, a servant is shown with a large pot which she is washing in the water barrel by the door of the house. Her face is turned away and she therefore does not distract from the scene. The artist's lack of spontaneity and denial of movement – even the gestures seem frozen – has meant that his reputation has perhaps suffered in recent years in favour of the more animated approach of Jan Steen (page 51).

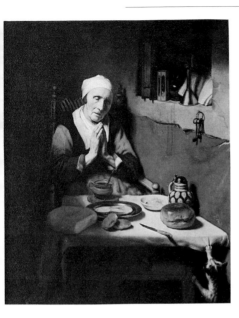

Maes (1634–93) was for a time a pupil of Rembrandt, and he learned a good deal about style from his master but nothing about content. He never took up the solemnity of Rembrandt's subject matter, but was adept at shadows and textures and the illusion of detail given by altering the focus in different parts of the picture. The old woman in prayer is one of the best of his few genre scenes; the rest of his enormous output consists of many hundreds of rather modest portraits. The old woman's face is acutely observed as are the still life elements on the table. The meaning of the picture is far from obvious; the old woman could be saying Grace as it does not look as if she has started to eat, but the picture is full of symbols which could convey some element of *vanitas*. There is an hourglass on the shelf, and while she prays the cat is pulling at the tablecloth in the hope of bringing a cascade of food onto the floor. The picture achieved great fame in the nineteenth century, but its anecdotal approach is less appreciated today in spite of the great skill with which it is painted.

The Sick Child

c.1665

Gabriel Metsu

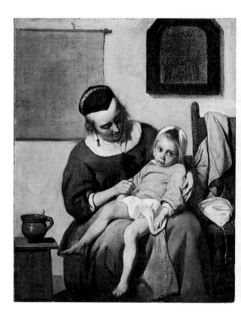

This small-scale picture is especially popular because it depicts a scene with which mothers through the ages have been all too familiar. The child is ill, inconsolable and fractious and since there is no obvious remedy, the mother's attention seems futile. It is unusual in Metsu's work to find such an effective sentiment as his morals and meanings are usually much less obvious. The technique is especially refined recalling his Vermeer-like *Music Lesson* (in the National Gallery, London). Indeed the technique but not the subject matter of this picture shows how close Metsu could come to Vermeer, especially in the sharp focus of the mother against the cool light of the background wall with its map and mirror.

Metsu (1629–67) worked in Leiden in the first part of his short career, concentrating on rather ambitious religious pictures. It was only later in Amsterdam that he came to specialize in these exquisite genre scenes. He was as skilled as ter Borch (page 26) in the depiction of silks and satins, although in this picture the textures are more homespun. His pictures have always been sought after by collectors, especially in the eighteenth century, and they are now very widely scattered. In common with so many of his genre specialist contemporaries Metsu suffers from not having painted a single outstanding masterpiece on which the rest of his reputation can hang – unlike, for instance, Asselijn and Potter (pages 25 and 98).

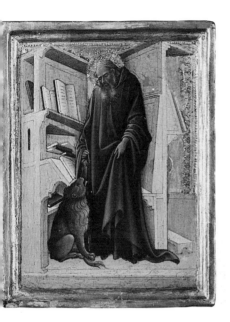

Although born in Siena, Lorenzo Monaco (c. 1372–c. 1422/4) was the leading painter in Florence in the years just after 1400 and remained so until the emergence of the young Masaccio in the 1420s. His major work included a fresco cycle in Santa Trinità in Florence and a dated altarpiece of the *Coronation of the Virgin* (1413) in the Uffizi. His considerable output is now widely scattered as his altarpieces, consisting of many panels, have been broken up. This little *St. Jerome in his Study* is still in its original gilded frame and formed part of a small diptych. Its equally delightful counterpart, *The Virgin of Humility*, survives in the Thorvaldsen Museum, Copenhagen.

Many legends grew up about St. Jerome in the Middle Ages and this picture includes the main ones. A cardinal's hat is seen hanging on the right, even though St. Jerome never achieved this distinction. The lion putting up his paw to the saint is part of the legend that St. Jerome pulled out a thorn from its paw and they became friends ever after. Although only twenty-three centimetres high, this small panel has all the grandeur of a large-scale work because of the emphasis on structure, both in the draperies and the study shelves. All the details are reduced to their simplifed essentials, which gives a sculptural quality to the work.

The Fishwife

1672

Adriaen van Ostade

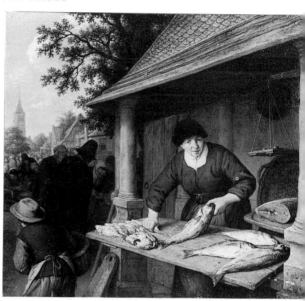

Adriaen van Ostade (1610–85) spent all his long career in Haarlem and he has always been recognized as the best, as well as the most prolific, of all the Dutch seventeenth-century painters of low-life genre. He painted the 'poor beggars, bordellos, children on their pots and worse', with the same lavish care that Metsu (page 38), Dou (page 28) and ter Borch (page 26) expended on the silks and satins of the better-off classes. Even though it is on a small scale, as is usual with van Ostade's work, each detail is well observed. Dutch shops and markets, bargaining, buying and selling are not depicted as often as might be thought. Here we are looking at the fish stall as an exercise in observation: there is a salmon steak, sole and crab and the woman is cleaning a large trout. There is no customer at the moment, although we can see the market bustle in the background. The treatment of the freshly-caught fish laid out on the stall is especially brilliant, with the scales glinting in the light. The fishwife herself is very well observed and is a real character rather than the standard peasant type, which the denigrators of this type of art often imagine to be the case. Although he painted a few landscapes, which are curiously like those of Rembrandt, and also some outdoor scenes, such as this, most of the artist's output was of interior scenes.

AMSTERDAM: RIJKSMUSEUM

Most of Ouwater's (1750–93) distinguished output is of canal scenes and views of Amsterdam and therefore this view of the exterior of a shop is not only exceptional in the artist's work but a rarity for the time. It takes up the idea Vermeer explored in *The Little Street* (page 52) of a frontal view of buildings from the other side of the road; but here the novelty is the exclusion of the sky, which is how it would appear if the artist's viewpoint was at street level. The pattern formed by the closely spaced windows seems to anticipate the experiments of twentieth-century abstract painters, but this is purely coincidental as the artists of this later period, such as Mondrian (pages 71 and 84), arrived at their geometry through their own experiments with naturalism and not by looking at the Old Masters.

The street outside the lottery-cum-bookshop is crammed with people, a contrast to the artist's view of the nearly empty Herengracht in the Amsterdam Historisch Museum (page 21). Ouwater has also recorded accurately the date on the building, 1728, as well as some literary allusions in the inscriptions. In this period the Dutch Republic was still a major publishing centre partly owing to the heavy censorship remaining in other countries such as France. It was profitable to publish in the Dutch Republic which had no restrictions, especially on works of a political or religious nature.

Giuliano da Sangallo and Francesco Giamberti

1480s

Piero di Cosimo

Although now separated and framed individually, these two pictures were intended as a diptych as is seen in the near continuity of the landscape background. Diptychs of this type are rare in Florentine art and this is a particularly precious survival. The painter, Piero di Cosimo (1461–1521), is perhaps best known for the portrait of *Simonetta Vespucci* in the Musée Condé at Chantilly. The sitters are father and son, cabinet maker and distinguished architect and sculptor. The Sangallo (left) is the more subtle portrait of the two. Sangallo's architecture was much influenced by the great Brunelleschi and the symbols of his profession appear on the ledge in front of him.

The Giamberti (right) is the more striking of the two pictures because it is a characterful portrayal of old age. In its realism there is likely to be some northern influence, as the work of van Eyck, Hugo van der Goes and Memlinc (page 96) was familiar to many Italian Renaissance artists. There is however an important difference. As an Italian, Piero di Cosimo was much more concerned with a linear approach than any of the northern masters. It has been thought that the Mass being said in the background suggests that the portrait was painted after the sitter's death, but the distinctive features give a strong impression of having been drawn from life. The two portraits have an interesting history as they belonged to James II of England and were taken over to Holland by William III of Orange.

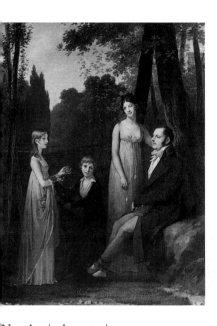

Neoclassical portraiture was concentrated in France during the Revolutionary and Napoleonic periods, and this large-scale work is no exception. Rutger Jan Schimmelpenninck was Legate of the Batavian Republic (which had been set up by the French in place of the old Dutch Republic) in Paris 1798–1802 and 1803–05. In 1806 everything changed again when Louis Bonaparte assumed the newly created Dutch throne. All the figures in this charming picture seem elongated and artificially elegant. Even though Prud'hon (1758–1823) embraced a Neoclassical style, he never adopted the hard-edged clarity which is seen in most of his contemporaries, especially in the work of Jacques-Louis David and his pupils. The portrait of the main sitter is especially sensitive – he looks attentive and alert – whereas the rest of the family might have been added for decorative reasons. The stylish elegance of the whole picture is a complete reversal of the Dutch tradition, which even in this period was dominated by a matter-of-fact approach.

The landscape setting also gives some idea of the new Romanticism which was creeping in after about 1800. Instead of the expected formal classical background, the sitters are shown in a woodland park, reflecting the influence of informal English landscape gardening on European taste. The artist is little-known outside France where most of his art remains. He was also a brilliant draughtsman both in pastel and chalk.

Jeremiah Lamenting the Destruction of Jerusalem

1630

Rembrandt van Rijn

AMSTERDAM: RIJKSMUSEUM

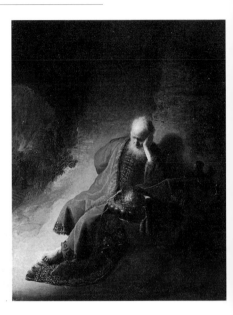

This is one of Rembrandt's (1606–69) most meticulous and successful pictures from his Leiden years; for an example of a youthful work produced four years earlier see page 124. Even though he was only twenty-four when he produced it, his precociousness is obvious as he had mastered illusionism, fine detail, balance of composition, and above all the ability to tell a narrative. The story is simple enough: Jerusalem the Holy City of the Jews is destroyed by Nebuchadnezzar, fulfilling Jeremiah's gloomy prophecy. Rembrandt's treatment of the subject is especially moving; he gives the figure of the prophet a gesture of contemplative melancholy. The picture's small scale, however, prevents the dramatic subject of the city's destruction having an overwhelming effect, and the whole is essentially without drama. There are a few indications of a young man's desire to show off, especially in such details as the prophet's clothes.

At this stage in Rembrandt's career there is no indication that the artist's style was to broaden out so dramatically, yet only two years later he was to paint the ambitious and commercially successful *Anatomy Lesson of Dr Tulp* (page 99). It is perhaps suprising in view of Rembrandt's modern status as one of the greatest artists of all time, that these pictures from the Leiden period were the most esteemed by collectors in the eighteenth and early nineteenth centuries.

The Syndics: The Sampling Officials of the Amsterdam Drapers' Guild

1662

Rembrandt van Rijn

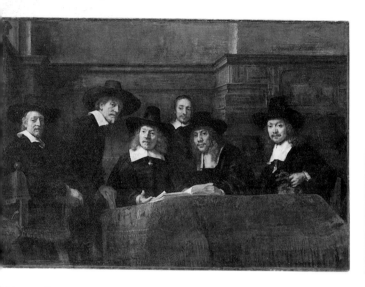

AMSTERDAM: RIJKSMUSEUM

This was Rembrandt's (1606–69) only commission of importance after 1660 and he rose to it with great aplomb. In the subject pictures Rembrandt's late style had become increasingly free in colour, drawing, and brushwork. This tendency is already visible in *The Night Watch* of twenty years earlier (page 46). Here the elevated position of these self-important sitters required a sober approach and Rembrandt had to tone down his visual fireworks even though we see him at his most brilliant in the tablecloth, whose jutting perspective is enhanced by a unique combination of texture and saturated colour. The fiery red acts as a stark contrast to the essentially black-and-white colour scheme of the rest of the picture.

Despite the dramatic differences between Frans Hals and Rembrandt for most of their long careers, comparison with Hals's late Haarlem group portraits (page 77) shows how close the two artists came to one another at the end of their respective careers. The irregular placing of the Syndics' heads is paralleled in Hals, as is the acute observation of character. There is the same sobriety, the same subduing of natural waywardness, with excellent and moving results in both cases. By the end of the nineteenth century *The Syndics* was considered to be the greatest picture ever painted by a Dutchman, with Hobbema's *Avenue at Middelharnis* in the National Gallery, London, a close second.

⭐ The Militia Company of Captain Frans Banning Cocq and Lieutenant Willem van Ruytenburch (The Night Watch)

1642

Rembrandt van Rijn

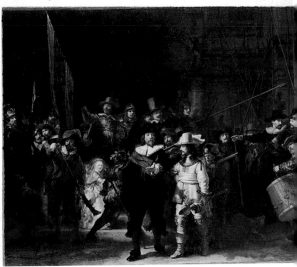

This is Rembrandt's (1606–69) largest, most ambitious, and most famous picture, and the most revered, if not the most liked, work in the whole of Dutch art. The circumstances surrounding its creation are prosaic enough: an Amsterdam militia company required one of the standard records of their membership, as had been the tradition since the late sixteenth century. Many of these group portraits are now collected together in the Amsterdam Historisch Museum (page 18). Rembrandt responded with an innovative composition of great grandeur and quirkiness in its treatment of light. It was this personal approach which was the picture's undoing at the time as the sitters were emphasized very unequally, some almost disappearing into the shadows. This was not a recipe for success as they had all paid the same sum to be included with equal prominence.

For the present day the picture's problem is that an increasing number of people wonder how it came by its fame and reputation as a work of towering genius. There is no easy explanation, but the painting is one of unprecedented grandeur for a Dutchman, and Rembrandt has rivalled the Italian Renaissance in splendour, texture, and a general amplitude not usually found in Dutch art. By failing to meet the descriptive requirements of the sitters, he has taken the picture away from the particular and raised it to the general. The figures emerging from a dimly lit gate have acquired, in spite of themselves, a timeless quality.

Unlike many of Rembrandt's (1606–69) other masterpieces, this painting was not rediscovered until the early nineteenth century, and its fame has slowly risen along with the gradual understanding of Rembrandt's independence from convention in his last years. There has been an unusually large amount of speculation about the picture's subject matter, none of it conclusive. Indeed the study of many of Rembrandt's religious pictures – and it is generally agreed that *The Jewish Bride* may well represent an Old Testament subject – has shown a carelessness with the detail of the story. Rembrandt was approximate in his rendering of biblical themes, concentrating on their emotional intensity rather than their symbolism. It is this ambiguity of approach which makes the painting so interesting for the modern observer. Of course, the picture is about two people who love each other and there are some couples in the Old Testament who might fit, but their precise characters cease to matter in the emotional haze in which we now see the work. The drawing other than that of the faces and the hands does not bear scrutiny as Rembrandt has abandoned all sense of anatomy and substituted the now famous slabs of red and yellow paint which seem incandescent. Recent cleaning has revealed an even greater depth of colour and freedom of brushwork than was previously visible in this world-renowned picture.

The Windmill at Wijk bij Duurstede

c.1670

Jacob van Ruisdael

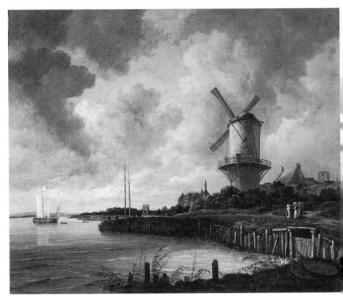

Along with *The Jewish Cemetery* (of which there are versions in Dresden and Detroit) this is Jacob van Ruisdael's (1628/9–82) best known composition. It deserves to be, but it is unusual in the general context of his art. The site of the windmill itself is a good distance from Amsterdam in the south of the country, and it shows that Ruisdael, unusually for many Dutch artists, was interested in travelling in order to select picturesque sites. The other artist who did this incessantly was Jan van Goyen (page 31). Although Ruisdael was concerned with topographical accuracy (see his view of Haarlem, page 102) this picture has been very deliberately composed. What at first sight appears naturalistic is in reality a balanced arrangement of the type achieved by Vermeer in his stylistically utterly different *View of Delft* (page 107). Even the cloudy sky is very carefully arranged to enhance the silhouette of the windmill and also to create a complex system of rhythms. Fromentin, the French nineteenth-century painter and critic, remarked that Ruisdael 'never painted a sunny day', but he understood grey ones. The exquisite tonal relationships between water and land were not to be seen again until the early nineteenth century with the observations of Constable and Corot, and Constable even copied Ruisdael's work in order to improve his powers of observation.

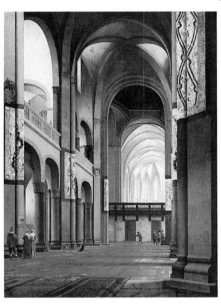

The contrast between this picture and the cool tones of Saenredam's
(1597–1665) *Interior of St. Cunera, Rhenen,* The Hague (page 103) could
not be greater. Here we have a church portrait of great splendour, which
seems to defy the general view that Dutch churches in the seventeenth cen-
tury had lost all their decoration. The Mariakerk in Utrecht was
Saenredam's favourite subject – he painted it from different angles both
inside and out no less than eleven times, which is in itself surprising in an
output of hardly sixty surviving paintings. Saenredam's technique is also
known as he visited Utrecht for a period of twenty weeks in 1636 and made
a series of very careful drawings – the one for this picture is in the Royal
Scottish Academy, Edinburgh. The church itself, unfortunately demol-
ished piecemeal in the nineteenth century, was a magnificent Romanesque
building with a later Gothic choir. Its decoration had partly survived the
depredations of the iconoclasts as the church was run by a rare surviving
order of Catholic canons who were tolerated in these largely Protestant sur-
roundings. Amusingly, in one of his views of the nave (Gemäldegalerie,
Kassel), Saenredam had a change of mind and painted out the surviving
decorations which he had originally put in the picture. Of all Saenredam's
church interiors this is the least austere and most lavish in detail, with its
glittering gold leaf on the columns.

The Merry Family

1668

Jan Steen

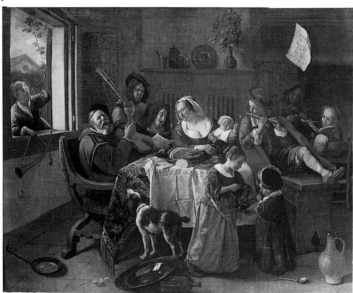

Merriment was Jan Steen's (1626–79) forte and this is one of his best essays in the genre. The painting is inscribed in Dutch: *Soo D(e) Oude Songen, Soo Pijpen De Jonge* – (*As the Old Sing, So the Young Chirp*). The moral is clear enough; the young soon learn the ways of their elders. Sometimes Jan Steen went further and depicted the deleterious effects of intemperance, but here he has been content to show the adults having a good time although the warnings are sinister. The fat child at the table brandishing a spoon looks as if it is already drunk and the two children in the foreground are teaching one another the ways of drink with a helping hand to the glass. The adults remain indifferent to the corruption of their offspring, but the household is obviously a prosperous one as there is a rich carpet on the table under the cloth and a large ham as the centrepiece. On the floor are the remains of fried eggs, pan and shells. Few painters in the seventeenth century could create such a wonderful sense of noise and disorder, with each activity isolated, delineated and then brought together in a wonderfully chaotic whole. It perhaps is no surprise that Jan Steen's status is now higher in the Netherlands than even that of Frans Hals.

The Harbour at Middelburg, Presumably with the departure of Elisabeth Stuart, Queen of Bohemia, called The Winter Queen, 12 May 1613

1625

Adriaen van de Venne

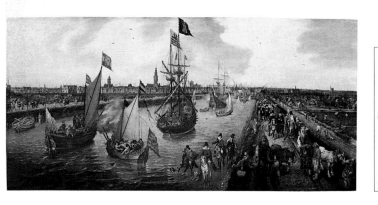

Most of Van de Venne's (1589–1662) work consists of small panels painted in monochrome of moral subjects related to the poor, sometimes even captioned with elaborate inscriptions. At 134 cm wide this is an unusually large work for the artist and unexpectedly depicts a specific event. Elisabeth Stuart, the 'Winter Queen', was a tragic figure in the history of the time. The daughter of James I of England and Scotland, her marriage to Frederik Elector Palatine and King of Bohemia meant that she spent most of her life living in exile in The Hague as a result of her husband's losing his throne in the Thirty Years' War.

The real interest here is the beautiful depiction of the canal, the shipping, the people and the topographical background. The figures in their elaborate costumes are carefully observed; the crowd has come out of the town to watch the royal departure along the canal leading from Middelburg to the sea at Flushing (Vlissingen) a few kilometres away. The long format of this picture is typical of Dutch painting before about 1630. After that date compositions tended to become squarer, incorporating more sky.

The Little Street

c.1660

Jan Vermeer

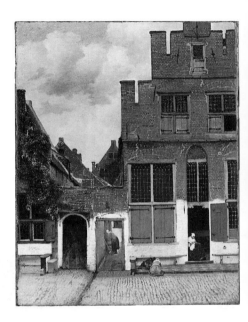

This is Vermeer's (1632–75) only street scene and one of his two outdoor scenes (see also the *View of Delft*, page 107). It is a masterpiece of simple observation and can be compared closely with de Hooch's *Three Women and a Man in a Courtyard* (page 36) which seems so immaculately idealized when the two pictures are observed. The day is a dull one, which eliminates strong contrasts of sunlight, and the view is taken from across the street which eliminates perspective. The town house is an old one, probably late medieval in origin, as were many of the houses in Delft, with larger windows inserted into the old fabric in more recent times. The cracks in the bricks have been repaired with different coloured mortar adding to the picturesque effect. There are many very tiny touches throughout which reveal Vermeer's intimacy of approach. The Dutch habit of whitewashing bricks up to a certain height creates an irregular line, and the shutters on the windows at street level are closed, perhaps as security or perhaps for privacy, as the ones on the far right are open. The figures appearing in the immaculately kept street and in the doorway are much more anonymous than is usual for Vermeer; they seem unaware of the painter's preoccupation, unlike the characters in many of his genre scenes. This picture was given to the Rijksmuseum by a Londoner, Sir Henry Deterding.

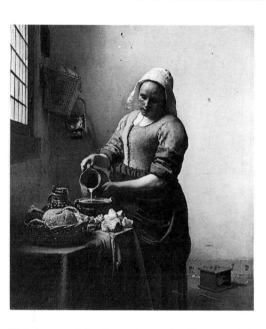

This is one of the few paintings by Vermeer (1632–75) which was not completely forgotten in the years after his death. It was remarked on in 1781, the year the English Royal Academician Sir Joshua Reynolds toured the Netherlands, and it stood out as a masterpiece then although Reynolds was not aware of who had painted it. The picture's reputation probably reached its height in the late nineteenth century, when it came to be seen as an example of domestic virtue, or more specifically, Dutch virtue. Even though the idea of domestic virtue has long been outmoded, Vermeer's unsentimental power of observation in this humble scene has never been surpassed.

As with many of Vermeer's masterpieces the composition and lighting are disarmingly simple. The maidservant endlessly pouring a thin stream of milk stands near a window close to the corner of a bare room. One of the artist's most brilliant but understated pieces of observation is the blank wall, with its record of the tiny imperfections in the bare plaster. In terms of the restricted blue and yellow colour scheme the picture is one of Vermeer's most intense works. The paint is more thickly applied than usual and this is also seen in the dots of light which define the bread in the foreground.

A Woman Reading a Letter

c.1665

Jan Vermeer

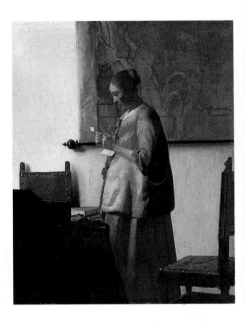

Vermeer's (1632–75) output was fairly small – only thirty-five or so pictures by him survive – and his reputation for intimacy has to be based on relatively few of these as so many of his paintings deal with other types of subject. *The Woman Reading a Letter* is the best example of these intimate works, in which the picture becomes almost a still life. The woman stands alone unobserved, reading a letter. This is a contrast to *The Maidservant Pouring Milk* (page 53) since we are more aware of the self-consciousness of the artist. The intimacy is complex because the spectator never knows what the woman is reading – whether she has received a love letter or something of a more trivial nature. There are no clues in the picture as there is only a map on the wall and a book on the table.

Every observer of this picture has been impressed by its understated technique. The blue of the woman's robe has a saturated intensity on its shadowed side and shimmers in the light on the other. The chair and map are arranged with a curious precision and make up a pattern rather than a description of an interior, which invites comparison with the matter-of-fact approach of Pieter de Hooch's *Woman and Child in a Pantry* (page 35). It was pictures of this type which impressed those twentieth-century painters who were more concerned with geometry than description.

Interior of the Portuguese Synagogue in Amsterdam

1680

Emanuel de Witte

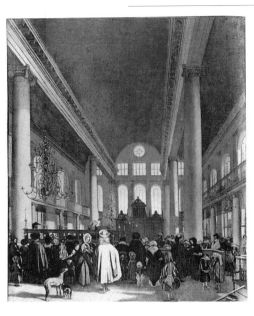

Most of de Witte's (1616/18–92) considerable output consists of depictions of the two medieval churches of Amsterdam, the Oude Kerk and the Nieuwe Kerk – or sometimes imaginary variations on them. He also painted a few exceptionally good fishmarket scenes. This picture is unusual for him both in that it depicts a synagogue and that the building is contemporary rather than medieval. Remarkably little evidence survives in present-day Amsterdam of the numerous and active foreign communities which settled in the city in its commercial heyday in the seventeenth century. The Jews were tolerated with far greater ease than in most other European countries at the time.

In terms of composition and perspective the picture rivals the achievement of Saenredam (page 49). The artist has adopted the same low viewpoint, almost on the floor, which makes the building seem so impressive, but there are great differences as well. De Witte was more interested in figures and textures than Saenredam, and his synagogue here is crammed full of people and, as was the custom at the time, their dogs. The light effect has all the subtlety associated with de Witte, even though he preferred stronger contrasts. There are so few representations of seventeenth-century minority worship that this picture assumes a historical importance equal to its artistic merit. It was bought by the museum from a London dealer as recently as 1949.

Address
Paulus Potterstraat 7,
Amsterdam
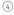 570 5200

Map reference
④

How to get there
Between Rijksmuseum and
Stedilijk Museum

Opening times
Daily 10–5. Closed 1 January

Entrance fee
G. 12. 50 adults; G. 5
children up to 17

Of all the museums in the Western world devoted to one artist this is the finest, and the reason for this is easy to see. The collection has a significant portion of the artist's output in all media. It is sympathetically displayed in a purpose-built museum of the 1960s which has weathered well, unlike many buildings from that period, and Van Gogh himself has not suddenly gone out of fashion as has happened with almost every other single-artist collection museum in Europe. The list of these is depressing, and includes Musée Henner, Musée Gustave Moreau, Musée Bourdelle (all in Paris), Musée Wiertz in Brussels, and the Lenbachhaus in Munich.

The story of Van Gogh's miserable life ending in suicide is well enough known, as is the absurdity of many tens of millions paid for one of his pictures in the 1980s. The collection presents a balanced view of his art, but Van Gogh is seen in isolation from his contemporaries. A problem for almost all the other collections of Dutch nineteenth-century art all over the Netherlands is that most of them lack the focus of a significant work by Van Gogh. It means that the general visitor never really understands the way in which Van Gogh reacted against the muted colour schemes of his contemporaries and yet at the same time was often moved by their sentiment.

For Van Gogh there is still a danger of over-praise because the artist is seen as a tragic figure and not always judged on his own merits. However, even to the sceptic, the power of his genius shines through in a beautifully displayed and well-ordered collection.

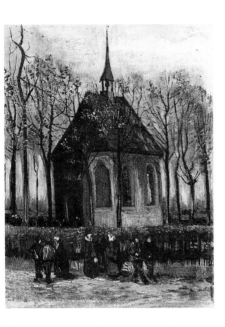

AMSTERDAM: RIJKSMUSEUM VAN GOGH

When he painted this masterpiece Van Gogh (1853–90) was at the beginning of his tormented career. He had already evolved a very personal and easily recognizable style which owed little to his contemporaries of The Hague School (well represented in the Museum Mesdag, page 113). Later in his career he was to absorb a rich variety of influences from Japanese woodcuts to French Impressionism, but at this early stage his approach was remarkably evocative. Even today in remoter parts of the Netherlands there are still a few small chapels surrounded by trees instead of neat villas. The artist has caught the feeling of a dreary grey and wet day as the figures with heads bowed leave the chapel and prepare to walk home. They seem poor, with no obvious Sunday best and no carriages and horses. The rural Netherlands where Van Gogh was brought up had none of the wealth of the Industrial Revolution.

Taken on its own merits and not seen as a prelude to the greater pictures that Van Gogh was to produce, this picture still retains its power to move. There is a curious intensity about the way that every detail is placed on the canvas with the rapidity that was to become his trademark. This ranges from the few remaining leaves on the trees to the movement of the figures.

Self-Portrait at the Easel at the Age of Thirty-five

1888

Vincent van Gogh

After Rembrandt, Van Gogh (1853–90) probably painted more self-portraits than any other Dutch artist. They are just as revealing as those of the older master and they are backed up by a wealth of biographical detail. Even without this extra information it is obvious that Van Gogh's powers of self analysis are remarkably acute, and the mirror has captured his intense concentration.

Painted while the artist was in Paris, the picture shows the inevitable contact with French Impressionism, and this is seen not only in the way the paint is laid on in dabs and thick strokes, but also in the way the colours are mixed. In the background and on the back of the canvas he is working on, there is a lot of Van Gogh's favourite pale acid green. The Impressionist technique of placing pure colour on the canvas and allowing it to mix optically is seen in the touches of the jacket, where small dabs of pure bright colour serve to intensify the blue of the garment. There are also bright dabs of colour in the hair and beard which, compared to the artificial colour schemes of some of his later works, seems naturalistic. The colours on the palette are even brighter than those in the rest of the picture, and this is a further concession to naturalism as nothing can compare to the fresh brilliance of the colours as they come from the tube.

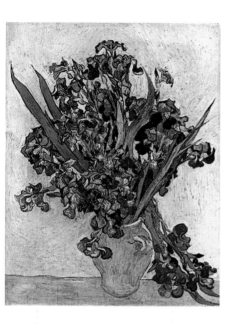

AMSTERDAM: RIJKSMUSEUM VAN GOGH

Since Van Gogh's (1853–90) *Irises* (albeit in another version) became the world's most expensive painting by a large margin there has been a double reaction to his pictures. Either they are seen as overpriced – how could such a simple picture be 'worth' so many tens of millions? – or conversely it is taken as a just affirmation of the artist's supreme talent, for which he received no rewards at all in his lifetime. These irises are less famous perhaps than the *Sunflowers* but no less good. Van Gogh understood the power of complementary colour in this instance, contrasting the purple-blue with the yellow-green end of the spectrum. Recent research has shown that artists responded to advances in chemistry which allowed paint manufacturers to provide increasingly bright colours unknown to the Old Masters.

These irises are not the classic Dutch iris (still beloved of florists) but the short-lived flag iris, which until the arrival of modern hybrids flowered in a deep purple hue, without the characteristic yellow beard of the Dutch variety. Van Gogh compensated for the delicacy and subtlety of the flowers by the violent treatment, especially of the dazzlingly brilliant yellow background. The vase is painted with the same brutality. The flowers themselves thrust into the vase without any sense of artistic arrangement take on an aggressive quality not seen in nature. The leaves, too, have a jagged energy and the whole reflects Van Gogh's tormented passion.

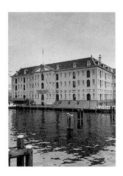

Address
Kattenburgerplein 1,
Amsterdam
☎ 523 2222

Map reference
⑤

How to get there
East of the railway station

Opening times
Tue to Sat 10–5; Sun and
public holidays 12–5
Closed Monday

Entrance fee
G. 12. 50 adults; G. 8
children 6–17; G. 10 seniors
over 65

Dutch seafaring – especially in the seventeenth century when The Netherlands was at its most powerful both economically and politically – is the theme of this collection, in which the paintings themselves only incidentally illustrate the country's great maritime tradition. This is generally true of all maritime collections, even the largest one in existence, The National Maritime Museum at Greenwich in London. The Scheepvaart collection has been built up very carefully in recent years and includes an example of most of the main marine artists of the seventeenth century except Jan van de Cappelle. As the museum is arranged on thematic lines exactly like the Historisch Museum, the pictures tell their story in the appropriate place and are not used to record the artistic developments of the time.

Unusually quite a few of the paintings show sea battles, a number of them with the English. Hendrick Cornelisz. Vroom's *Battle with the English* of 1614 and Willem van de Velde 11's *The Battle at Kijkduin* of 1672 are examples, as is one the English like to forget by Willem Schellincks, *The Expedition to Chatham in 1667*, an occasion on which the English fleet was burned by the Dutch.

It has to be admitted that the real interest and charm of the museum is the collection of model ships of every possible type, and there is, as might be expected, a collection of real barges and ships which are more conveniently exhibited on the water outside.

Museums of twentieth-century art are by their very definition in a state of flux, and the Stedelijk Museum, especially since 1945, has been at the cutting edge of all that is innovative both in Dutch art and on the international scene. For some this can be seen as a criticism because it constantly denies the idea of permanence (The Gemeentemuseum in The Hague, page 83, has encountered this problem). Some people feel that the museum must freeze the past and preserve it, yet this was the case of the great nineteenth-century collections of the Netherlands, for example the Museum Mesdag in The Hague (page 113), and they went out of fashion en bloc.

The Stedelijk Museum at the same time has not neglected its permanent collection's growth, although the late nineteenth-century part of it, taking over from the Rijksmuseum just down the street, is rarely on show. The museum can exhibit in a reasonably even way almost all the major innovative developments of twentieth-century painting, although it has few works that are not part of major trends and as a result there is little British or Spanish twentieth-century art. There are a few unexpectedly significant holdings such as those of Malevich (page 70), and when the permanent collection is hung the visitor will find good examples of work by the major figures in the period 1900–1950.

American art of the post-war period is given rather more than a token representation; lack of this has been the undoing of most other European collections of twentieth-century art which aim to be comprehensive. Of all the Dutch museums this is the one which is the most internationally conscious, always looking for new trends from abroad, and as a result continuing to involve itself in controversy.

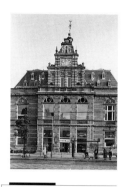

Address
Paulus Potterstraat 13,
Amsterdam
℡ 573 2737

Map reference

How to get there
South of Rijksmuseum Van Gogh, within sight of Rijksmuseum

Opening times
Daily and public holidays
11–5
Closed 1 January

Entrance fee
G. 8 adults; G. 4 children
7–16; G. 3 children under 7

Self-Portrait with his wife Quappi

1940–41

Max Beckmann

In the context of Max Beckmann's troubled career and violently expressive art this picture is curiously intimate. Beckmann's paintings were labelled as degenerate by the Nazis, and his work, along with that of many of his contemporaries, was banned from public exhibition and sold or given away by the museums which had collected it.

In 1937 Beckmann (1884–1950) emigrated from his native Germany to Amsterdam where, astonishingly, he remained throughout World War Two, apparently left alone by both the Dutch and the occupying German forces. Most of Beckmann's art is about anger in some form, and in most people's eyes it is an anger justified by his observation of human violence and folly. Even in this everyday scene of a well-dressed couple on their way out of the house there are dark hints in the artist's facial expression, and in the frenetic way the ground is painted by their feet. Successful portraiture has been a relative rarity in twentieth-century avant-garde art, perhaps because of the dominance of photography. Beckmann's work as a portraitist, especially the depictions of himself and his wife are an unusual achievement. Yet the artist takes no pleasure in the paint surface: we are always denied the sensuality of texture and colour, and he gives everything his characteristic black outlines, at the same time allowing black to dominate the whole canvas.

The Dam Square, Amsterdam

c.1898 or later

George Hendrik Breitner

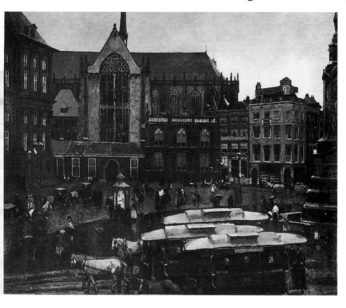

Breitner (1857–1923) was one of the most prolific and successful Dutch painters of his time; some people find it hard to believe he was friendly with Van Gogh. His approach was a mixture of *fin-de-siècle* elegance for his figure subjects of ladies in kimonos and a more gritty realism for his views of Amsterdam. He relied quite heavily on photography to achieve his apparently unposed effects. The viewpoint here is very similar to the one painted in the seventeenth century by Jan van der Heyden (page 7) and shows how little the buildings had changed in the intervening two hundred years. Unlike van der Heyden, Breitner was interested in the human element in the foreground, the bustling figures and the horse-drawn trams. The real focus of the picture, however, is the carefully depicted south side of the Gothic Nieuwe Kerk. In his treatment of the buildings Breitner kept to the seventeenth-century tradition of accuracy, but there the similarity ends. He achieved the effect of a rain-soaked, grey winter day, the leaden sky and the damp air, changed in modern times by the introduction of neon lights. Breitner avoided the picturesque tendencies of so many of his contemporaries; his reliance on the camera prevented those little rearrangements which trivialize so much late nineteenth-century topographical painting.

Montagne Sainte-Victoire

c. 1888

Paul Cézanne

The curious shape of the Montagne Sainte-Victoire dominates the hilly landscape around Aix-en-Provence. In the usually clear light the bare rock takes on a variety of hues reminding one more of Monet than Cézanne (1839–1906). The fact is that Cézanne was interested in form and not in the fall of light. All his landscapes have little feeling for light and not much of a sense of place. Cézanne used a distinctive, and all too easily imitated type of brushstroke to define form. These usually sloping strokes often went against the natural lines of the subjects which gave his pictures, especially the later landscapes, the illusion that they were made up of little pieces of coloured geometrical chippings arranged to create an impression of monumental solidity.

It was this search for the geometry of natural forms which made Cézanne the precursor of Cubism, even though that movement was more concerned with the purity of geometry than its relationship with nature. The Montagne Sainte-Victoire is a curiously empty picture, with no sense of movement or even atmosphere. The cottages and the buildings are reduced to an impure geometry, the shimmer of the sun on the mountainside is turned into purple cross-hatching, and the exceptional clarity of the Mediterranean light is denied. Cézanne was at odds with his times and his extreme approach brought much contemporary criticism. After his death he was acclaimed as the most significant figure to influence the development of twentieth-century art.

Portrait of the Artist with Seven Fingers

1912–13

Marc Chagall

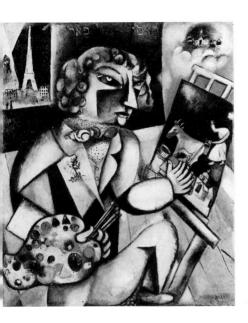

It is unfortunate that Chagall's (1887–1985) later and weaker work achieved great popular acclaim at the expense of his earlier and much more serious paintings. Late in life he was at his best when designing for stained-glass rather than in his pictures of flying figures with their repetitious colour schemes. Chagall was in Paris from 1910 to 1914, and this picture is cluttered with uneasily assimilated influences. The self-portrait is crudely Cubist in its inspiration, while the colour is hesitantly Fauve, in the sense that it is unrelated to the forms it defines. The composition too has overtones of Picasso's work, especially that from 1906 onwards. The artist has included a number of symbols from his native Russia and combined them with a rather obvious Eiffel Tower in the left background. This young man's eclecticism is unexpectedly moving when logic would indicate that this should not be so. The picture's success lies in its peculiar intensity, the sharp form of the figure, the fantastic designs on the palette and the slightly ridiculous seven fingers on the hand. Too many of Chagall's pictures repeat this approach but in a much looser and less controlled way. Quite obviously he could not keep up the eccentricity seen here without the danger of degenerating into cliché.

Man and Animals

1949

Karel Appel

It is now perhaps difficult to understand the aspirations of the generation of artists in their early maturity after the traumas of World War Two. There was definitely the feeling that art had lost its direction and even Picasso's *Guernica* (Museo Nacional Centro de Arte Reina Sofia, Madrid) changed in its significance once Europe was at peace again. Dutch artists felt this as much as their French counterparts, and at the end of 1945 a loose association of young painters from the Netherlands and Scandinavia was formed in Paris, entitled COBRA (Copenhagen, Brussels and Amsterdam). The leading figures were Karel Appel (b. 1921), Asgar Jorn, Constant and Corneille, and they promoted a vigorous style which gave free expression to the unconscious mind. The group, predictably, aroused a good deal of indignant opposition from the art establishment of the time although the Stedelijk Museum itself was keen to support and to exhibit their work. This example by Karel Appel might be termed one of the tamer efforts of COBRA, and it shows some influence of the subversive French artist Jean Dubuffet. There has been a conscious and partly successful effort to return to the vision of the child – the figures and animals are drawn as children see them but are arranged in an entirely adult way. Colour too plays an important part in COBRA pictures, although here it is difficult to avoid the feeling that this owes much to Matisse.

The sitter was the wife of the postman in Arles in the South of France. She is known as *La Berceuse* because she holds a cord to rock a cradle. Now isolated from its intended setting the picture seems vibrant enough, but Van Gogh (1853–90) wanted it to be flanked, in triptych form, by versions of his *Sunflowers*. The brilliance of the yellows in the sunflowers would have further emphasized the powerful green which dominates this version of the composition (there are four more). Van Gogh himself wrote of the picture: 'A woman in green with orange hair standing out against a background of green with pink flowers. Now these discordant sharps of crude pink, crude orange and crude green are softened by flats of red and green.' From this we know that Van Gogh was conscious of the eccentric nature of his approach, taking its consequences but at the same time keeping faith in its validity. The artist's extreme violence with brushstrokes and his uncanny ability with powerfully discordant colour was precisely what has made him so appreciated and admired in the twentieth century. For all its exaggerations of colour and general aggressiveness the picture retains its humanity: the sitter's hands are sensitively intertwined, her expression pensive and, in the final analysis, benign. It is this humanity, a compliment applied always and sometimes unthinkingly to Rembrandt, which transforms Van Gogh's apparently bold and insensitive approach into something far greater.

Improvisation 33 (Orient I)

1913

Wassily Kandinsky

Compared to Malevich (page 70) or Mondrian (pages 71 and 84), Kandinsky (1866–1944) was a romantic, but he too rejected narrative in painting and proclaimed in his book *On the Spiritual in Art* (published in 1912) that the elimination of recognizable forms allowed the spectator to concentrate on the spiritual aspects of a picture. Once Kandinsky had evolved his very personal style – via some early experiments derived from Fauvism – he varied it relatively little. The ingredients were the same, but they are hard to define because they are essentially formless. They interlock, overlap, and sometimes seem to float in isolation, but there is always a sensual delight in colour and a strong sense of movement.

This painting from 1913 is a relatively early one in which there is still a hint of recognizable form even though there is no intended subject matter. So many of Kandinsky's shapes were personal to him and were not derived from the type of painstaking observation of nature undertaken by Mondrian. In his writing Kandinsky related his pictures to music, but this remains difficult to understand because such ideas could well apply to all abstract art. Perhaps Kandinsky's association of specific colours with specific musical instruments acted as a way of explaining his art to his largely mystified contemporaries.

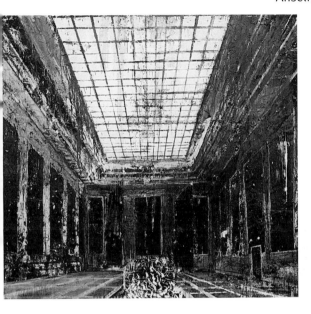

This picture represents a startling return to tradition in the 1980s, when a good many of the artistic taboos of the previous fifty years disappeared. The vast hall with the fire in the centre is Hitler's Reichskanzlerei in Berlin, built in 1938. The fact that it is derelict and on the brink of ruin might suggest that the young German post-war artist Anselm Kiefer (b.1945) is not entirely in sympathy with this symbol of Nazism. To take such an emotive line on a deeply sensitive political issue could be seen as a violent revolt against the most important trend in twentieth-century art, which is to remove meaning of an anecdotal or didactic nature from painting and to concentrate on the emotive power of form, colour and design. As a concession to modernism Kiefer is experimental with his medium. There is straw mixed with the oil paint and pieces of painted paper stuck onto the canvas, and for good measure the artist has knocked a few holes in it. These extras do not detract from the traditionalist power of the picture, which harks back to all the dark interiors painted by the Old Masters. Kiefer's rebellion is to return to the old values while at the same time painting with direct simplicity.

Suprematism (Supremus no. 50)

1915

Kazimir Malevich

It is one of the curious phenomena of many extreme forms of modern art that the artist explains his work for the benefit of the bewildered public. Malevich (1878–1935) was no exception. As a young avant-garde artist in the early part of the century his art was genuinely influenced by the Fauves, but by the outbreak of World War One in 1914 he had taken his experiments with pure form to an extreme which was to set the pattern for much twentieth-century abstract art. This was based on the belief that painting should divest itself of all meaning, be it symbolic or realistic, so that it was reduced to form alone. Malevich termed this 'Suprematism', and this example from 1915 is one of the most powerful of the group of thirty-six canvases in the Stedelijk collection.

The forms are applied to the canvas with great precision, although their disposition might appear arbitrary to the point of confusion. The colours, mainly reds and black, are also very carefully balanced and modulated. Not surprisingly Malevich's paintings were considered degenerate by the Nazi authorities in Germany in the 1930s (this applied to both Beckmann and Kandinsky too, see pages 62 and 68), and even now, in the late twentieth century, works derived from Malevich still masquerade under the designation of avant-garde or modern.

Mondrian's (1872–1944) painting developed towards an extreme which the artist was at pains to explain. His approach was curiously but coincidentally similar to that of Malevich, in that he felt it was only through both pure form and pure colour that true freedom of expression could be found. Painting was to be reduced to a limited number of elements, unsullied by any literary or anecdotal references. To a great extent Mondrian succeeded in this because in his mature canvases he achieved a geometry which has been appreciated ever since, for its own sake. Perhaps unconsciously his severe rectangles and squares reflect the proportions and ideals of avant-garde architecture of the 1920s, where the geometry of the building overrode its decoration.

This particular composition is rather more elaborate than some of the later works of the 1930s, although right at the end of his life in the 1940s in *Broadway Boogie Woogie* (Museum of Modern Art, New York) Mondrian became much more rhythmic and decorative. Here too the colour is quite elaborate and carefully balanced, with the three primaries (red, blue and yellow) being set against the three neutrals (white, grey and black). Although hard to see in reproduction, these pictures are executed in conventional oil paint, with their brushstrokes perfectly visible and one can see evidence of careful adjustment in the colours and the exact positioning of the black lines.

Train of the Wounded

1915

Gino Severini

This is one of the masterpieces of Futurism, a movement still little appreciated outside Italy. The Futurists embraced the idea of technology and were not afraid of attempting to depict the impossible: speed, machines in action, and above all transport, especially cars and trains. Their methods varied from artist to artist – Boccioni, for example, preferred to use highly coloured abstract forms to create a sense of movement. In this picture Severini (1883–1966) has chosen the symbols of Cubism to create a pattern of movement, while emphasizing the painting's meaning rather than pure geometry. Although twentieth-century technology was in its early stages at the time this picture was painted in 1915, it was already being used on a previously unimaginable scale. Italian soldiers suffered serious and humiliating defeats at the hands of the Austrians in the early stages of World War One, with much loss of life. Here a train of wounded soldiers moves at great speed to its unspecified destination. The images of war – the wayside, the train and newspaper headlines – hurtle upwards pell-mell. For the Futurists the war was the means to an end, the need to create a new art which defied all previous traditions.

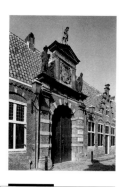

Frans Hals is closely linked with the cultural history of Haarlem, and the vistor is usually more surprised than disappointed to find that the museum named after him contains a series of magnificent group portraits of the city's militia companies but few single portraits so familiar from museums elsewhere. The group portraits form the core of the museum's collection and the early ones are arranged spectacularly in a large room while the later ones are arranged equally dramatically in a small room. Visitors intent on making the most of these masterpieces can easily overlook the fact that the Frans Hals Museum, in common with museums in Utrecht, Leiden and Dordrecht, offers a concise history of painting in the city during the sixteenth and seventeenth centuries.

There are modest examples of the other great Haarlem painters of the seventeenth century, such as Jacob van Ruisdael. Less well-represented, however, is the late fifteenth century, and since there is no work by Geertgen tot Sint Jans who worked in Haarlem, we have to make do with an unusual view of the West Indies by his pupil, Jan Mostaert. The dominating figure in the earlier part of the collection is Cornelis van Haarlem, who can be difficult to appreciate because of his extravagantly Mannerist style. More impressive is the sequence of portraits by Jan Verspronck, the conventional Haarlem portraitist of the time of Frans Hals. His coolness both of colour and observation act as a welcome antidote to the exuberance of Hals.

Most of the nineteenth-century pictures in the collection are not usually on view. Sadly the interiors of the building are not in their original state although the modern methods of display are especially sympathetic. The interior is an excellent example of how an old building (in this case an alms house) can be adapted to modern needs quite unrelated to its original function.

Address
Groot Heiligland 62,
Haarlem
✆ 023 319 180/ 164 200

Map reference

How to get there
South of the main square,
reached on foot

Opening times
Mon to Sat 11–5. Sun and
public holidays 1–5

Entrance fee
G. 6.50 adults; G. 3 children
10–18 and seniors over 65;
children under 10 free

The Knightly Brotherhood of the Holy Land at Haarlem

c.1527–29

Jan van Scorel

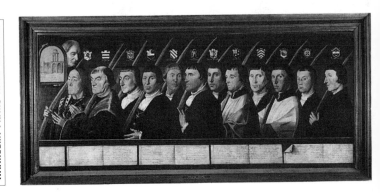

It is not known when group portraits were first painted in the Netherlands, but this example is one of the earliest to survive, and was painted by Jan van Scorel (1495–1562) to commemorate the members of a religious confraternity. Compared to so many of the later masterpieces of this genre, especially those by Frans Hals (page 77), this one seems rigid and formal. The arrangement, however, is very clever, with a double line of sitters which allowed the heads to be placed very closely together. It is the treatment of these individual heads which betrays Jan van Scorel's abilities. Each one is a careful piece of characterization, with the differing ages and hair colours – even though they wear their hair in the same distinctive style – being given particular attention. Their glances add enormous variety; the two elderly ones on the left seem pompous and even vexed. Since they are adorned with their furs they are obviously the most senior in the group. The sitters' status descends towards the right, and third from the end the artist has included his self-portrait. Compared to the others his gaze is especially intent as he would have been looking in a mirror to record his own features.

The acuteness of observation and confidence of the drawing is a clear enough indication that Jan van Scorel was one of the most talented painters in the northern Netherlands of his time, and when the Bishop of Utrecht was elevated to the Papacy in 1523 it was Scorel who accompanied him to Rome as court artist.

HAARLEM: FRANS HALS MUSEUM

Even though Haarlem is so indelibly associated with Frans Hals, the painters who preceded him should not be neglected. The one who received the most important commissions – especially that for the decoration of the Town Hall – was Cornelis van Haarlem (1562–1638). His style was shamelessly derived from Italian models even though he never went to Italy but took his inspiration from engravings and drawings. He was drawn to the exaggeration of form and brilliance of colour which became fashionable in mid sixteenth-century Italy, but to a lesser extent in northern Europe.

The Massacre of the Innocents is the centre panel of a very large altarpiece whose wings were painted earlier by Maerten van Heemskerk; they are also in the Frans Hals Museum. The surprise factor in this picture is the way in which the incredible number of figures is incorporated into a swirling movement which anticipates the Baroque. This whole picture is unusual for Dutch art at the time. Frans Hals's approach was to be very different, but ironically, when Hals painted his first group portrait of the Civic Guard at Haarlem, it was from a group painting by Cornelis van Haarlem of 1583 (also in the museum) that he took the arrangement of the figures.

View of Haarlem from the Noorde Spaarne

c.1600

Hendrick Cornelisz. Vroom

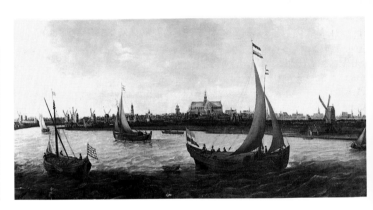

Even though he is somewhat forgotten nowadays, Vroom (c. 1562/3–1640) achieved a considerable reputation in his lifetime and major works by him were in the British royal collection in the time of Charles I, when he was certainly regarded as the leading seascape painter of his generation. Vroom was a careful observer of shipping but he did not develop the skill in the depiction of light and atmosphere that is seen so well in the next generation of marine painters, Willem van de Velde the Younger (page 106) and Jan van de Cappelle (page 27). Instead Vroom's pictures have a strong narrative content, and this one has a well-balanced combination of seascape and topography.

The Noorde Spaarne was the river which flowed through the east side of Haarlem, although like almost all Dutch waterways it has been altered by drainage over the centuries so it is difficult to pinpoint the exact place from which the view was taken. The silhouette of Haarlem is painted in a matter-of-fact way with the great medieval church of St. Bavo dominating the centre. In spite of its breadth, and even grandeur, the comparison with Jacob van Ruisdael's rendering of the subject (page 102) is perhaps invidious. Vroom's son Cornelis Hendricksz. Vroom was one of the earliest of the Dutch pure landscapists and he did have some influence on the young Jacob van Ruisdael.

The Regents of the Old Men's Alms House, Haarlem

1664

Frans Hals

This picture along with its pendant (see below) occupies a special place in group portrait painting, as it was far ahead of its time. In his successful early years during the 1620s Frans Hals (1581/5–1666) had painted a magnificent series of lively group portraits of the Militia Companies of Haarlem. After about 1630 such pictures were commissioned far less frequently and such commissions did not go to Hals. For most of his mid career he concentrated on severe but animated portraits of the middle classes of Haarlem, and by about 1660 his work was going out of fashion. Hals was nearly eighty when he painted this striking group, with its elaborate rhythms emphasized by the rakish angles of the sitters' hats.

The Regentesses of the Old Men's Alms House, Haarlem

1664

Frans Hals

Much more severe than its male counterpart, this picture is perhaps the greatest by Frans Hals. The sitters are placed in rigid poses, and its mysterious magic lies in the relentless observation of the difficult old women, although the one on the extreme right appears a little more kindly than the rest. Hals's powers of observation of character are unsurpassed and all the words usually applied to Rembrandt's late style – psychological penetration, humanity and freedom of brushwork – are applicable here. Traditionally placed in a small room rather than a large gallery, these two group portraits overwhelm by their physical grandeur and poignant truth about the crankiness, waywardness and general difficulty of old age.

View of an Inner Court of the Ancient Monastery of the Dominicans, Haarlem

1813

Wouterus de Nooy

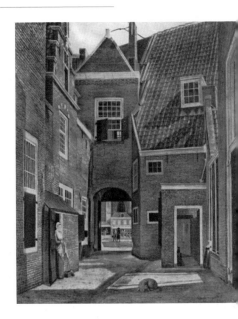

It is not often that a post-medieval masterpiece exists with hardly any information about the artist. Wouterus de Nooy's (1758–1825 or later) work is so rare that this is one of only two pictures by him in a Dutch public collection. It depicts the courtyard of the Dominican Friary in Haarlem. By the end of the sixteenth century the Dutch Republic had suppressed the monasteries, and their buildings were either demolished or adapted for secular use. Here there is little evidence of the medieval origins of the building, as it appears to be mostly of the sixteenth and seventeenth centuries. The powers of observation in this picture are especially acute, which makes it exceptional in the context of Dutch painting of the time which is so often repetitive. The artist has captured the fall of light, and the textures of the bricks and pantiles which combine to make a richly patterned surface. The living elements are kept to a discreet minimum and appear almost inanimate. The dog is fast asleep in the centre of the courtyard and a black cat lurks in the doorway on the right. Even the human figures are static: a woman is seen standing in the doorway on the left, her broom and duster abandoned by her side.

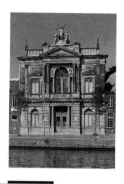

The Teyler Museum is really for the specialist but is none the worse for that. It is the only Dutch collection to preserve an eighteenth-century atmosphere, both in its building and in the curiosity of its collections. The eighteenth century contributed the geological specimens, the spectacular scientific instruments and the splendid library. The nineteenth century added an entire collection of contemporary landscapes, all by the main academic painters of the period. Long out of fashion, these pictures are now appreciated again.

For the art lover the real reason for the pilgrimage to the Teyler is the Old Master drawings, a collection formed in the eighteenth century and still, in terms of quality, a rival to the great European cabinets of drawing. Only a few of these drawings are on view at any one time but a selection is usually available, very carefully protected from exposure to light.

The focus of the drawings collection is the series of breathtaking drawings by Michelangelo. Also noteworthy are the delightful sheets by the landscapist Claude Lorrain, only represented in the Netherlands by paintings in Rotterdam, and the small group by Rembrandt is outstanding. There are some spirited figure drawings by Raphael and a comprehensive representation of all the main Dutch seventeenth-century draughtsmen, including a beautiful view of Rhenen and its church by Saenredam (see page 103 for the interior of the church).

Address
Spaarne 16, Haarlem
 023 319 010

Map reference
⑧

How to get there
Just to the east of the market place

Opening times
Tue to Sat 10–5; Sun and public holidays 1–5. Closed Monday

Entrance fee
G. 7.50

Standing Nude

c.1504

Michelangelo Buonarroti

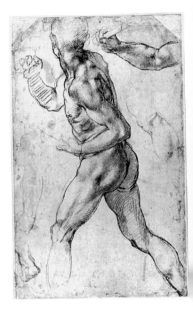

Michelangelo's drawings, together with those of Raphael, are unsurpassed in the art of the Italian Renaissance for their depiction of human anatomy, their inventiveness and their insight into the artist's working methods. Michelangelo (1475–1556) drew consistently throughout his long career, only rarely making a finished drawing which could be seen as a work of art in its own right. When he received a major commission, most famously the Sistine Chapel ceiling, he tried out many ideas. These were a mixture of anatomical observation and a general working out of compositional problems. The Teyler Collection contains several drawings for this most famous of ceilings. This drawing, however, is one of a group made for a large and complicated composition, *The Battle of Cascina*, which showed soliders surprised while bathing. The whole composition has not survived, but there is a good copy of it in the collection of the Earl of Leicester at Holkham Hall, Norfolk. Most Renaissance drawings of the human figure tend to be rather static and this one is unusual for its observation of movement. Michelangelo also used the paper for the study of arms, and the back of the sheet contains a male torso and a number of further studies of legs.

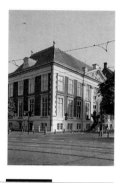

This newly constituted museum in a delightful old building near the Mauritshuis fills a need which every city has to make a visual and tangible record of its history, illustrious or otherwise. The Hague was a federal capital rather than the seat of a powerful court, and the Stadhouders of the Netherlands who resided there had only military power and could not raise taxes to increase their personal wealth. There was consequently not a lot of artistic activity in the town until towards the end of the seventeenth century under the aegis of Stadhouder Willem of Orange, who became King of England and Scotland as William III. He encouraged artists, but by this time Hals, Rembrandt and Vermeer were dead, and since Willem spent most of his time in England, most of his pictures by Dutchmen were kept there.

Rembrandt had painted an extensive Passion series for the Stadhouder in the 1630s, but this passed out of the Orange family at the beginning of the eighteenth century. Willem died childless with no close relatives and the hereditary Stadhoudership passed to distant Frisian cousins from whom was descended the distinguished collector Willem V (see the Schilderijenzaal, page 119).

The visitor to the museum therefore has to make do with a relatively modest show. The seventeenth century is represented with a few good quality views of The Hague, fishmarkets, vegetable markets and general topographical scenes. There is a superb sequence of eighteenth-century views of the town, not noted for their inventiveness, but very skilfully painted. Their value as social documents is immense, and comparison with British or French art of the period is especially telling: neither school recorded with any interest, let alone accuracy, the appearance of the main urban centres. There are a few notable exceptions, but no European city outside the Netherlands can even begin to rival The Hague's collection of eighteenth-century city views.

Address
Korte Vijverberg 7, Den Haag
 070 364 6940

Map reference
⑨

How to get there
In the historic centre, close to the Mauritshuis

Opening times
Tue to Fri 11–5; Sat and Sun 12–5. Closed Monday

Entrance fee
G. 5 adults; G. 3 children under 12

View of the Hofvijver seen from the Korte Vijverberg, The Hague

1762

Paulus Constantijn La Fargue

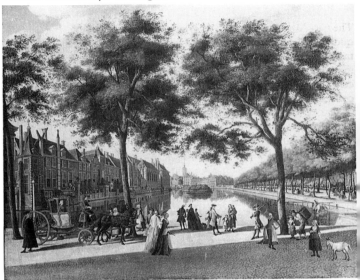

This formal view of the historic centre of The Hague by La Fargue (1729–82) remains more or less unchanged today, even though on all sides everything is altered out of recognition. The medieval complex of the Hall of the Knights, dating from the thirteenth century, is on the left, although the facades facing the water are mostly seventeenth-century. On the extreme left is the side of the Mauritshuis (page 86) with its cornice jutting out. In the centre distance is the eccentric hexagonal tower of the medieval Sint Jacobskerk.

Apart from its topographical accuracy the charm of the picture is in its human interest. The gentleman in the coach has been identified as Ludwig Ernst, Duke of Brunswick-Wolfenbüttel, who was in The Hague as regent for the young Stadhouder Willem V. All the other figures are excellent pieces of social observation. A lawyer stands deep in thought next to the coach, figures converse in the centre, and in true Dutch style a woman energetically sweeps the cobbles – a necessity given the number of horses on the streets. A small area of the Vijver (pond) has been fenced off so that horses could drink, as is shown happening on the right.

The City Museum of The Hague has had a chequered history representing some changes in taste, not all of them fortunate. It began as a modest collection of mainly Dutch seventeenth-century paintings supplemented by a growing collection of nineteenth-century works, chiefly of The Hague School, which have now returned to esteem after a long period of neglect.

The dramatic change which transformed the museum into one of twentieth-century art dispensed with a number of the seventeenth-century paintings. The collection has been continuously successful as a museum of twentieth-century art, covering most of the main Dutch painters of this century who, apart from those associated with COBRA (page 66), tend to have only local reputations. The exception is Piet Mondrian, who is represented by a wonderful and comprehensive collection.

There are also good examples of international modern art including works by Monet, Braque, Feininger, Kandinsky, Rouault, Schwitters and Severini. The museum attracted a great deal of attention in recent years when it proposed to sell works by Picasso, provoking stormy reaction on both sides. Sales would provide a handsome sum for future acquisitions of avant-garde modern art, thus keeping the museum alive. However, the opposition thought it shocking that a major museum should part with key works in the evolution of twentieth-century art, especially as Dutch collections are not notably rich in the work of Picasso. The paradox is unsolvable because the very essence of the modern art 'museum' is that it should be active and not static.

Address
Stadhouderslaan 41, Den Haag
✆ 070 338 1111

Map reference

How to get there
Some distance from the old centre, towards Scheveningen

Opening times
Tue to Sun 11–5. Closed Monday

Entrance fee
G. 8 adults; G. 5 children 4–12; children under 4 free

Lighthouse at Westkapelle

1909

Piet Mondrian

In his early years Mondrian (1872–1944) was much influenced by the Fauve movement in France, especially the arbitrary application of bright colour to describe form. The Fauves used colour as unrelated as possible to its natural counterpart, and Mondrian adopted this with perhaps too much of a young man's enthusiasm. By the time he came to paint the *Lighthouse at Westkapelle* he had toned down his palette and was already working towards the transformation of his forms into geometry. There is still the convention of the low viewpoint and the natural perspective of the great tapering tower, but the lighthouse was a good exercise. At this point it is hardly possible to predict the dramatic way Mondrian was to turn.

Composition no. 6

1914

Piet Mondrian

This picture shows a half-way stage from an experiment with Cubism seen in several of Mondrian's early pictures towards the perfectly ordered squares and rectangles of his final years. There is already a strong sense of balance but the meticulous technique is not yet fully developed. The subtle pinks, greens and greys are painted with a good deal of emphasis on texture, the brushstrokes are strongly visible and the artist's habit of building up successive layers of paint has led to some serious cracking of the surface. This deterioration is irreversible and it has defied the techniques of modern conservation.

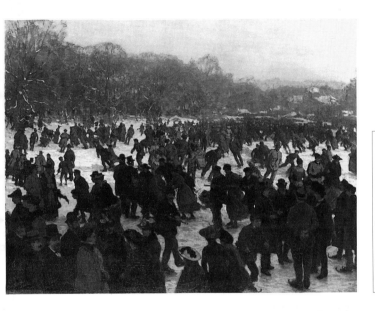

Although Tholen (1860–1931) was of a younger generation than the painters of The Hague School (of which Matthijs Maris and Joseph Israels are represented on pages 115 and 116), he was deeply influenced by them. This picture is an astonishing achievement of the new realism also seen in France in the work of Bastien-Lepage and in England in the paintings of the Newlyn School.

City dwellers are out crowding the ice in the Hague Woods, a rural enclave already surrounded by urban development at the time the picture was painted. The animation of the scene goes back to the origins of this genre in the work of the Bruegel family and Avercamp (see page 87), but the poses have been changed into contemporary ones. Each figure in this especially complex picture is well observed and at the same time integrated into the whole. As in the earlier pictures, the coldness of the day is deeply felt, as is the misty distance. Tholen is still highly regarded in the Netherlands, but as his work is hardly represented outside the major Dutch collections he remains little known elsewhere. When the fashion for this type of realism disappeared in the middle years of the twentieth century many museums, including the Dutch ones, were tempted to consign pictures such as this to the shadows of their reserve collections.

THE HAGUE: MAURITSHUIS

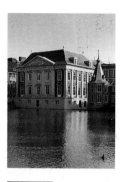

Address
Korte Vijverberg 8, Den
Haag
✆ 070 346 9244

Map reference
⑪

How to get there
Historic centre location

Opening times
Tue to Sat 10–5; Sun and
public holidays 11–5. Closed
Monday

Entrance fee
G. 10 adults; G. 5 children
under 18

In view of the collection's tiny size, the impact of the Mauritshuis is all the greater. The visitor is prepared by the compactness of the building – like an overgrown doll's house partly surrounded by water – for walls which are closely packed without being crammed, although the sheer number of visitors often masks the intimacy of the collection. Each room is hung in the way a private collector might choose, and there is no rigidity or sterility in the arrangement, which is even moved around periodically. Vermeer's *View of Delft* (page 107) is flanked by two modest pictures which enhance the effect; the curators know not to place a spectacular Rembrandt on the same wall. There will always be much discussion as to the precise favourites. Those who seek impact will go to Potter's *Young Bull* (page 98) and Rembrandt's *Anatomy Lesson* (page 99), while those who seek the intimate and contemplative will find Vermeer's *Woman with the Pearl Eardrop* (page 108) and Fabritius's *Goldfinch* (page 91) to their taste.

But this is perhaps to miss the point. Unlike many of the great collections of the world the Mauritshuis is a metaphysical garden of discovery, rather than an ordered place in which a particular route must be followed. Historic portraits of the House of Orange line the stairs in serried ranks, while Rococo decorations by the eighteenth-century Italian Pellegrini dominate the main saloon downstairs, and Holbein and Chardin, Rubens and Van der Weyden exist within a few feet of one another. Upstairs the Rembrandts are closely hung, without any sense of artistic pecking order. It is this apparent disorder which allows visitors to discover the unexpected. Controversy over the authenticity of some pictures by Rembrandt may rage on in books and newspapers, but in the Mauritshuis no irritating labels with the latest journalistic information are allowed to sully our contemplation.

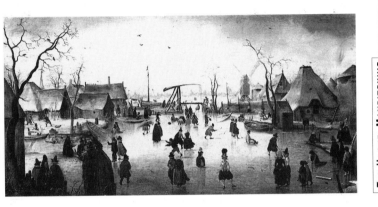

THE HAGUE: MAURITSHUIS

Avercamp (1585–1634) was a pioneer of Dutch winter scene painting, although he evolved his style from the winter scenes of the Bruegel family of Antwerp. Like the Bruegels who influenced him, Avercamp combined a meticulous technique with an ability to capture the special quality of the northern winter light. Sometimes the towns in the backgrounds of his pictures are recognizable. He favoured the buildings in the remote town of Kampen in the province of Overijssel, where he worked for most of his career. The element which Avercamp took over most brilliantly from the Bruegels was his observation of people. Each figure has its own character and action: some of them converse or gossip on the ice, others rush around on their skates and sometimes well-dressed couples parade themselves in front of the bustling scene. The number of authentic pictures by Avercamp is very limited and no satisfactory explanation has been offered for this, especially as he had so many imitators who never achieved his standard. Until the 1920s this picture was in the Rijksmuseum in Amsterdam, but it was sent to The Hague as part of the exchange system which brought the Piero di Cosimos to the Rijksmuseum (page 42).

Banquet Still Life

c.1660

Abraham van Beyeren

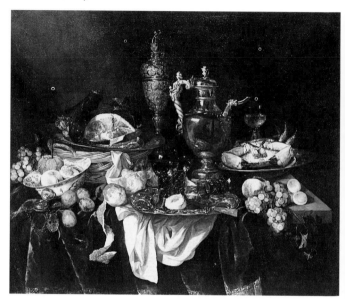

The Dutch have always been known for their austerity in dress and religion, and their interest in images of the opulent and extravagant can strike viewers as ironic. Some Dutch still life paintings are of simple subjects: dead fish on a slab, oysters (not then the luxury they are now) or humble breakfast pieces. In this lavish picture by Abraham van Beyeren (1620/1–90) we have the reverse, since every object is a luxury, especially the elaborate silverware and the imported Mediterranean fruits such as lemons and peaches. Some explanation has been offered for pictures of this type in their possible moral message: they could have been reminders of the vanity and futility of materialism. If this moral really did exist in the seventeenth century it did not deter collectors from highly prizing these elaborate and brilliantly coloured pictures. Van Beyeren was the most skilled specialist of the banquet piece and his own little vanity was that he recorded his own features reflected in the tankard in the foreground of this picture. In spite of the representative nature of the collection of seventeenth-century painting in the Mauritshuis this magnificent work was not acquired until 1977, and it is tempting to see it as an indicator of a new age of materialism about to dawn.

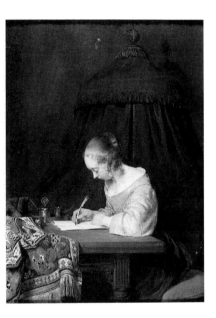

This is one of ter Borch's (1617–81) most intimate genre pieces although he was also a portrait specialist (see page 26). So much of the artist's effort went into the depiction of texture, especially that of silk and satin, that many of his genre pieces have been dismissed merely as exercises in skill. Yet here there is a moment of great intimacy as the letter writer concentrates on her missive, although there is no obvious symbolism to tell us whether she is writing a love letter or whether she is merely doing the household accounts. Her dress is of simpler stuff than is usual for ter Borch, but he could not resist lavishing his expertise on the crumpled Turkey carpet which the writer has pushed to the edge of the table in order to make a hard surface on which to work. Along with so many of ter Borch's genre pieces this picture is on a minute scale. It came from the celebrated Six Collection in Amsterdam – Jan Six was painted by Rembrandt – but at the time of dispersals from that collection in the 1920s the public spirited Sir Henry Deterding of London acquired the picture and donated it to a grateful Mauritshuis.

⭐ A Flower Piece

c.1610

Ambrosius Bosschaert the Elder

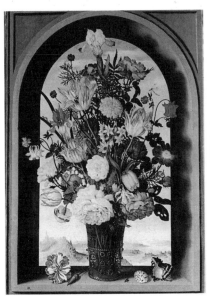

At first sight this elaborate flower piece appears somewhat naive, especially as an impossibly large number of flowers are jammed into a glass beaker far too small to hold them. To increase the implausibility the flowers appear to come from different seasons: tulips, roses, fritillaries, flag irises, columbines, lilies-of-the-valley, carnations, narcissi, grape hyacinths, heart's-ease and bluebells do not all bloom at once. The artist Ambrosius Bosschaert the Elder (1573–1621) was the founding father of the Dutch school of flower painting, although only a handful of paintings by him survive. He was strongly influenced by that most brilliant of the Flemish flower painters, Jan Brueghel the Elder, whose arrangements were even more elaborate than this. The reason for this complex juxtaposition was that the emphasis was on a decorative ensemble rather than a careful observation of nature. Each bloom was painted from an elaborate drawing and as a result the same flowers appear in other pictures by the same artist. This large-scale work is exceptional because of the delightful and fantastic landscape background seen through the open niche. The symbolism of the flowers suggests vanity; a hungry caterpillar crawls up a tulip stem and a sinister large bluebottle rests on the ledge by the glass beaker.

This small picture has long been famous as an example of illusionism. Its painter Carel Fabritius (1622–54) was certainly a pupil of Rembrandt for a short time and is also thought to have been the master of Jan Vermeer of Delft. Fabritius's career was cut short as he was killed in the explosion of a powder magazine in Delft in 1654 that wiped out almost a quarter of the town. Each one of the artist's dozen or so surviving pictures is distinctly individual. This one painted the year of his death is thought to have been part of a small cupboard door, which would explain both the format and the illusionism: perhaps a real small bird was kept behind it.

The artist's technique was sometimes derived from Rembrandt but there is no trace of that influence here; the palette is lighter, the execution tightly controlled and the colour understated. The texture is achieved by variations in the thickness of the paint rather than the mastery of smooth surface found in so many works by Dutch seventeenth-century painters. Only in the concern with light is there any affinity with Vermeer, especially in the treatment of the pale background. Like many of the famous pictures in the Mauritshuis it was acquired relatively late in its long history. It was bought by Abraham Bredius, the Rembrandt expert and director of the collection in 1896 (see pages 110–112 for his museum and collection).

Alexander the Great Visiting the Studio of Apelles

c.1620

Willem van Haecht

This Flemish picture is one of the small number of surviving paintings showing a specific art collection; not one of these exists for any Dutch collection of the period. It shows the paintings of the rich Antwerp collector Cornelis van der Geest; the artist Van Haecht (1593–1637) was the keeper of his collection. The subject of Alexander the Great visiting the studio of Apelles, the most brilliant painter of Ancient Greece, who is painting the portrait of Alexander's betrothed, Campaspe, adds variety to an already elaborate scene. A number of the pictures lining the walls of Van der Geest's gallery are known today in various prominent collections. Especially obvious is the large battle scene by Rubens in the bottom row, centre left, which is now in Munich, and the exquisite mythologies by Correggio in the upper right, which are in the Kunsthistorisches Museum, Vienna. Van der Geest himself was painted by none other than Van Dyck and the small head of him is in the National Gallery, London. There are only three known paintings of this type by Van Haecht and the total from the entire Flemish school is very limited. This is one of the relatively small number of works that came from the cabinet of Willem V (see Schilderijenzaal Prins Willem V, page 119).

Miniature Portrait of Queen Elizabeth I of England

c.1570

Nicholas Hilliard

THE HAGUE: MAURITSHUIS

At the time of the Renaissance when there was such intense artistic activity all over Western Europe, the main backwater was England, and it was only in the field of miniature painting that any real talent emerged. Even this was probably the legacy of the medieval tradition of manuscript illumination in which English artists had excelled. Hilliard (1547–1619) was by far the most skilled artist working at the court of Queen Elizabeth I and even he was labouring under the difficulties imposed upon him by an artistically insensitive Queen. Her face was at all times to be depicted without shadows and this explains the permanently blanched look of her features; she obviously disapproved of Italian notions of chiaroscuro. Yet there were no restrictions on the depiction of her dress, jewellery and ruff, and it is astonishing that so much accurate detail could be compressed into a space barely four by three centimetres. The opulence of the dress and the age of the sitter would seem to point to a relatively early date in the Queen's long reign, but even in her last years the Queen's orders remained effective as her face never appeared to age. The miniature has been on loan from the Rijksmuseum in Amsterdam since 1951.

A Watermill

c.1665

Meindert Hobbema

Watermills must have been a common sight all over the Dutch Republic in the seventeenth century, but very few of them remain. Hobbema (1638–1709) was especially attracted to the picturesque possibilities they presented. He was trained in the early 1660s in the studio of Jacob van Ruisdael (page 102) but soon abandoned Ruisdael's austere and ordered approach for a lighter palette and very much prettier details. This charming mill, if it ever existed, was Hobbema's favourite and it turns up in a similar picture in the Rijksmuseum, Amsterdam. Hobbema was more preoccupied than Ruisdael with the details of the scene than with the overall effect. This may have been why his reputation faded after his death, whereas Ruisdael always seems to have been appreciated. Hobbema's reputation was dramatically revived in the nineteenth century with the rediscovery of his now most famous picture *The Avenue at Middelharnis*, which is in the National Gallery, London. He was not particularly prolific and he gave up painting in about 1670, spending the rest of his long life as a wine gauger in Amsterdam. His work was particularly favoured by English and later American collectors, and most of his pictures are to be found in the US.

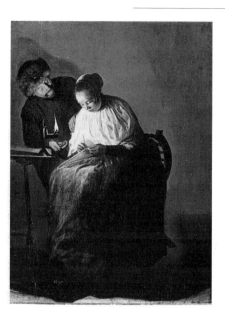

It is likely that Judith Leyster (1609–60) was taught to paint by none other than Frans Hals and she certainly married the productive Haarlem genre painter Jan Miensz. Molenaer. She was, however, rather more discriminating than her husband both in her choice of subject matter and her technique. Her approach was often to reinterpret well-worn themes in an original way, as in this instance where a mature man is shown offering money to a younger woman. The scene is lit by candlelight and we can assume that the man's intention is to pay for the woman's favours. The viewer never finds out the woman's reaction to the proposition as she remains resolutely preoccupied with her reading matter.

Leyster here rises above the usual easy interpretation of the subject with a much more subtle approach that leaves the viewer guessing. A similar sense of doubt is often seen in the genre pieces of Jan Vermeer of Delft, where the way the figures are reacting to one another is not always obvious. Leyster did not usually paint night scenes – they were more often depicted by Utrecht artists – but so great is the skill shown here that one would imagine that she was a specialist.

A Man

c. 1480

Hans Memlinc

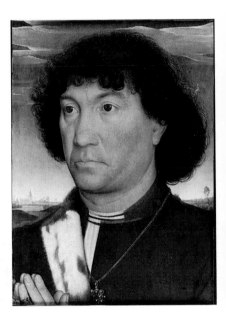

This earnest middle-aged man has not been identified. The painting almost certainly formed half of a diptych, the missing half being a standard *Virgin and Child*, a type which Memlinc (working 1465, died 1494) painted on several occasions. Realistic portraiture in the Netherlands was the innovation of Jan van Eyck, and Memlinc was one of the best continuers of this tradition. The sitter's features are observed with a haunting intensity which is only found again in the sixteenth century in the portraits of Hans Holbein the Younger, who is also represented in the Mauritshuis. Memlinc often introduced unobtrusive backgrounds to his portraits, in this instance a distant landscape. The scale is less than life-size and this picture is especially precious as only about a dozen panels of this type by Memlinc survive. The artist had many distinguished pupils and followers, especially Gerard David who continued the tradition in Bruges where they both worked. David himself was less interested in portraiture but this was taken up by the next generation in Antwerp with Joos van Cleve and Quentin Metsys. The painting was bought for the Mauritshuis in 1894.

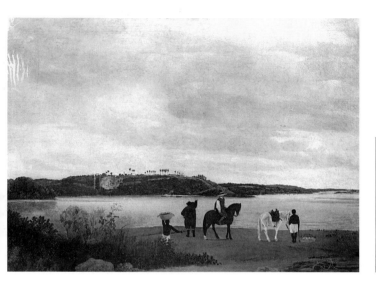

The Dutch wrested colonial territory in Brazil from the Portuguese who had originally colonized it. One artist of consequence, Frans Post (*c.* 1612–80), went out there at the request of the Dutch Governor, Jan Maurits of Nassau. Many of Post's numerous depictions of Brazil look resolutely Dutch with the surprise addition of the odd palm tree. This picture, however, manages to depict the tropical landscape with conviction. The artist's long inscription on the back of the canvas describes the site and even notes 'this is how the Portuguese ride their horses'. Although Post's composition may not show much originality this work is of great historical significance because it forms an accurate record of Dutch colonial activity, the sparseness of the settlements and the feeling of utter remoteness. In some pictures we see Portuguese Baroque churches already falling into ruin, overgrown with exotic plants. Dutch colonial activity was based on the desire to bring back wealth to the mother country, and while they did not always succeed in this, Dutch maritime influence by the middle of the seventeenth century had covered most of the globe.

1647

Paulus Potter

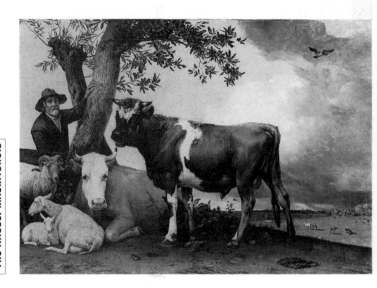

Visitors who come to the Mauritshuis for the first time may not be expecting a near life-size bull painted by an artist of whom they have heard very little, Paulus Potter (1625–54). To add to the surprise, the bull and its companions are set in a realistic landscape where there are strong contrasts of light and shadow, a naturalistic effect not seen again until the nineteenth century. Of all the paintings in the Mauritshuis, this is the one which has the most impact, not just because of the scale, which is impressive enough, but because the artist has understood both the anatomy and the character of the animal, including its potential aggression. Most of Potter's few surviving pictures are sensitive animal pieces on a very much smaller scale. There are one or two remarkable exceptions, such as *The Bear Hunt* (page 120) and *The Revolt of The Animals* in the Hermitage, St. Petersburg. The latter is one of the most revolutionary paintings of the period, consisting of a series of scenes in one picture, in which the animals revolt, try the hunter, convict him for animal murder and finally roast him on a spit. Although we know next to nothing about Potter since there are no surviving documents covering his short life, he must have been the only painter of his time to have had such sensitivity to animals and their exploitation.

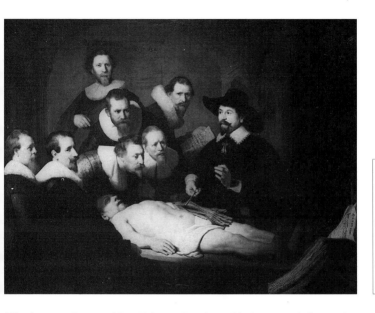

THE HAGUE: MAURITSHUIS

The Anatomy Lesson of Dr. Tulp was Rembrandt's (1606–69) first major commission on his arrival in Amsterdam from his native Leiden in 1632 at the age of twenty-six. The scene was common enough at the time – the public dissection of the corpse of an executed criminal – not as some macabre retribution but in the interests of medical science. The chief doctor, Nicolaes Tulp, dissects the forearm and hand, surrounded by his medical colleagues in a specially designed theatre. The public would have been able to witness the event. The apparently awkward nature of the composition is partly explained by the fact that while Rembrandt was making an elaborate record of the doctors for posterity, he was also concerned with the theatrical nature of the scene itself. This masterpiece has often been criticised for these compositional problems, which is hardly surprising as so important a commission had gone to such an inexperienced young man. Much later in his career Rembrandt painted an equally elaborate but much more successful composition of an anatomy lesson, but only a fragment of this survives in the Amsterdam Historisch Museum. This picture finds itself in The Hague because in the early nineteenth century the Amsterdam Surgeons' Guild sold the painting to increase their pension funds and it was bought by the King of the Netherlands, Willem I, for the Mauritshuis.

Self-Portrait as an Old Man

1669

Rembrandt van Rijn

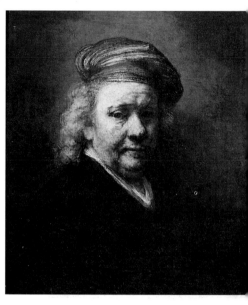

Rembrandt (1606–69) was preoccupied with self-portraits throughout his forty-year career, and it is now thought that those from the end of his life are the most profound and moving. Most artists have made a formal statement about their appearance at some point, but for Rembrandt it became a recurrent theme as he painted upwards of forty pictures of himself. Three, including this one, date from the last year of his life. His face has become flabby with age, his eyes tired and he has allowed his hair to grow longer. It is a near miracle that none of the acuteness of observation has left the artist as he looks so carefully at his real appearance rather than trying to create an idealized version of the so-called dignity of old age. The technique is also extraordinary. At this stage in his career Rembrandt was taking liberties with the then perceived limitations of oil paint, and was starting to rely on violent contrasts of texture and sharp and soft edges. The turban is painted with the bold strokes of a loaded brush while the hair is suggested with thick paint dragged lightly over the texture of the canvas. Modern viewers tend to over-interpret the impact of all this careful observation and imbue the whole with Freudian values. In fact Rembrandt's view of himself in old age is easily paralleled in such works as Titian's late portrait of himself. The relative fame of this picture is recent; it was bought for the Mauritshuis as recently as 1947.

The sitter was the Bishop of 's-Hertogenbosch and was reputedly Rubens's (1577–1640) confessor. The picture is a clear enough indicator of Rubens's mastery as a portraitist, an aspect of his art that has been much neglected in recent years. His famously rapid brushwork was used for the sketches for his large compositions, and when working on a large scale he painted with great breadth and vigour. It was only in the more disciplined genre of portraiture that he had to concern himself not only with likeness but with an accurately finished surface. Indeed, it was this apparent lack of finish that was one of the main causes of Rembrandt's difficulties with his patrons. Here, even though Rubens was restricted by the religious garb of the sitter, the concentration on the animation of the face is striking. The Bishop gazes straight out at the spectator and the feeling of life is emphasized by the apparent movement of the hand. Few painters, Rembrandt included, had the consummate skill to bring off this illusion of movement, and it shows that Rubens's reputation in his lifetime as the most prodigiously skilled artist of his time was entirely justified.

View of Haarlem with the Bleaching Grounds

c.1660

Jacob van Ruisdael

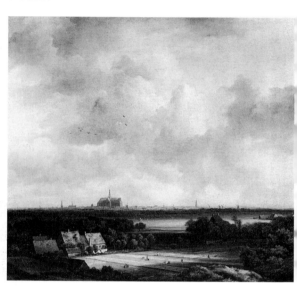

The distant view of Haarlem fascinated Jacob van Ruisdael (c. 1628/9–82) and he produced a series of subtle variations on the same subject rather in the way Monet was to do with his Rouen Cathedral series late in the nineteenth century. The unusual aspect of this variant is the high viewpoint, which must have been taken from a church tower or another tall building as there are no hills. The essence of these small-scale works is their immense sense of distance, the horizon dominated not just by the silhouette of the medieval church of St. Bavo of Haarlem but the magnificent bank of clouds. Ruisdael was particularly sensitive to the intermittent sunshine common on this type of day. The lighting effect is entirely cool and the only warm accents in the picture are the red roof tiles of the cottages in the fore-ground. There is an extra interest in this version as it shows the Dutch custom of laying out long swathes of linen to be bleached by the sun. Linen was of far greater importance in that period than in later times owing to the lack of cotton, which was an imported luxury. These pictures by Ruisdael are so esteemed by the Dutch they are given the affectionate soubriquet of *Haarlempjes*, literally 'little Haarlems'.

Interior of the Church of St. Cunera, Rhenen

1655

Pieter Jansz. Saenredam

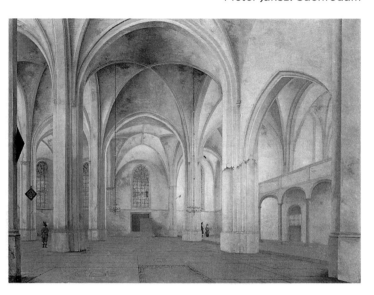

Dutch medieval church interiors remain little known, especially to visitors from abroad, as they are almost always closed. Some of them can, however, be studied in the exquisite depictions of them by Saenredam (1597–1665) who recorded both the exteriors and interiors of a good number of churches, although he avoided the medieval buildings of Amsterdam and The Hague. The Reformation in the sixteenth century had denuded all Dutch churches of furniture and decoration, reducing their interiors to whitewashed preaching halls and burial grounds. The exception to this rule was the Mariakerk in Utrecht, which Saenredam also painted (page 49). He made very careful perspective drawings of his subjects which he later, and sometimes many years afterwards, worked up into meticulously detailed paintings which are remarkable for their accuracy. Nothing distracts from the bare simplicity of this fifteenth-century Gothic interior, although from the outside the church has an unusually elaborate tall tower. Worshippers had to stand to listen to the Protestant sermons which were the central act of Christian worship. Even though Saenredam might be accused of preoccupation with detail and obsession with perspective he also had a Vermeer-like fascination with light. The whole of this picture is suffused by a pale and filtered light which raises it above the norm for interior painting.

Girl Eating Oysters

c.1660

Jan Steen

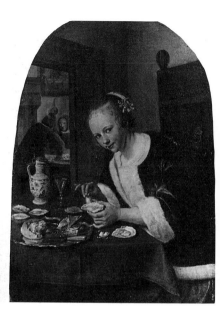

Human foibles, from sexual innuendo to domestic chaos, are found in almost all of Jan Steen's (1625/6–79) enormous output. Indeed, in modern Holland badly regulated households are named after Jan Steen himself. Here Steen's technique is rather more refined than usual owing to the picture's very small scale – it is only twenty centimetres high. The girl looks knowingly at the spectator without the slightest sense of guilt that she is eating the oysters for a specific purpose – they are an aphrodisiac. Her appetite appears insatiable as even more oysters are being prepared in the background. Steen's pictures do not have the elegant gloss of ter Borch (pages 26 and 89) or Metsu (page 38), but the artist is an acute observer of the human condition. The oysters, condiments, bread, glass and pitcher are seen in a natural disorder which is the exact opposite of the perfect balance of almost all other still life and genre scenes. Unusually for Steen there is also an exquisite colour balance of the blues of the Delftware and the tablecloth and the deep red of the woman's luxurious jacket.

Rumor Erat in Casa
(There Was a Noise in the House)

1740

Cornelis Troost

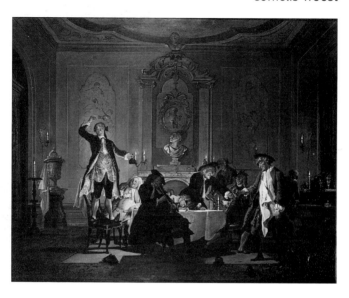

This pastel belongs to a series of five humorous scenes in the Mauritshuis produced *c.*1739–41 by Cornelis Troost (1697–1750), who was certainly the best Dutch genre artist of the first half of the eighteenth century. This was because he did not rely slavishly on the seventeenth-century precedents which were the general undoing of most Dutch painting of the time. Instead he approached the subject freely, with an added sense of humour found only rarely in the seventeenth century, but especially in the work of Jan Steen. The general title of the series is 'A Company of Friends of the House of Biberius' – the funniest one being the last: *Those who could walk did, the others fell.* The present scene is one of bedlam after dinner when the gentlemen who appear throughout the series are drunk; there is no evidence at all of ladies having been present. One of the company has stood on a chair and is declaiming loudly while the others appear to be reacting noisily, or heckling. The picture is a careful piece of social observation from the details of the costume and interior decor to the facial expressions of the intoxicated men. The skill of the painting is all the more striking when it is remembered that pastel is perhaps the most difficult medium of all to handle.

Ships in the Roads

c.1670

Willem van de Velde the Younger

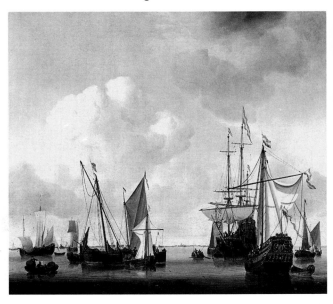

By common consent the younger Van de Velde (1633–1707) was the most skilled and accurate of all Dutch seascape painters of the seventeenth century. His career began in the Dutch Republic, but the second half of his long life was spent in England producing paintings of sea battles against the Dutch for the English monarchy. There is an anecdote that King Charles II was not a little worried that his pet artist might suffer accident or worse owing to his insistence on painting sea battles from close quarters. The artist's later pictures are more variable because of the violent nature of their subject matter and are much less consistent than the exquisite calm scenes of his earlier career.

This seascape is one of the artist's most ambitious calm pieces, where a large number of ships of different types are meticulously arranged and observed. The yacht in the right foreground is that of the States General and would have been used for inspecting the fleet. The picture does not show a specific event; instead there is a strong emphasis on the compositional relationships between the boats and at the same time a delight in the elaborate artifice of their silhouettes against the sky. Van de Velde achieves a near-perfect stillness, although Dutch weather is rarely this serene.

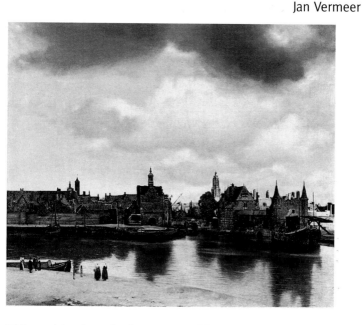

This exquisite picture has become one of the icons of Dutch art for its very uniqueness. It was not rediscovered until the early nineteenth century when Vermeer (1632–75) was still unknown. The composition is disarmingly simple, half of it being occupied by sky and then a band of buildings and water with a sandbank in the foreground. For all its apparent realism the artist has greatly adjusted the elements, some of which survive in present-day Delft, especially the elegant Gothic tower of the Nieuwe Kerk seen in the sunlight slightly right of centre. Most of the rest of the town is in shadow with a few pinpoints of light catching the rooftops. The whole is painted with an eerie clarity unique not only in seventeenth-century art but in any period. Parts of the work, especially the architecture, have an enamel-like quality in their detailing with Vermeer's familiar dots of light to describe form. The treatment of the clouds, however, is rather more naturalistic – there is none of Jacob van Ruisdael's attempt to arrange them into natural architecture. Another contrast with Ruisdael's work is the uncanny stillness; the water hardly ripples and the figures seem inexplicably static.

Head of a Girl

1660s

Jan Vermeer

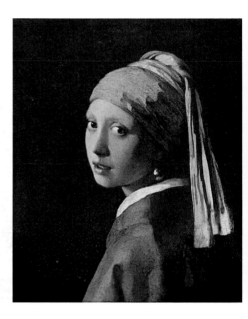

Although far from being his most skilled picture, this enigmatic head of a girl has become one of Vermeer's (1632–75) most popular works. It was not rediscovered until the late nineteenth century when it was sold at auction for a few pence. There has been a lot of speculation both as to the identity of the sitter – whether or not she is one of the artist's children – and as to the painting's meaning. A good number of Vermeer's genre pieces clearly contain sexual innuendo, but here the statement is more subtle. There can be no doubt that the girl has a 'come hither' look, but this is no real proof of any sexual meaning. Nevertheless, the slightly parted lips and the soft expression of the eyes suggest a mood of great intimacy of the type that is found in such pictures as Vermeer's *A Woman Reading a Letter* (page 54). The uniqueness of Vermeer's approach in pictures of this type – for there is only one other like it, in the Metropolitan Museum of Art in New York – cannot be over-emphasized. Even in his own time such work existed in a vacuum. It is impossible to understand how such a moving and beautiful picture should not have found favour with Vermeer's contemporaries or how it could have been consigned to oblivion for more than 200 years after the artist's death.

Lamentation over the Dead Christ

1460s

Rogier van der Weyden

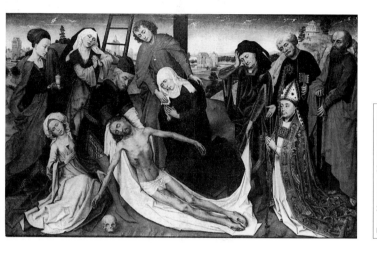

The donor of this magnificent work, Pierre de Ranchicourt, was appointed Bishop of Arras in 1463, the year before Van der Weyden's (*c.* 1400–64) death. It is therefore likely that the picture was completed after the artist's demise by pupils or assistants. The composition was certainly initiated by Van der Weyden and this is especially obvious in the complex relationships between the figures and the intense realism of the facial expressions. The weakness in the execution, if it is one, is in the slight softening of the drawing. Van der Weyden himself retained a hard and linear quality in all his work. This picture is a good example of a type of art which does not always find favour at the present time, but only because it is unlikely to be completely by the famous master and consequently exists in a kind of limbo. Yet Van der Weyden's workshop was in fact very active and well-trained and in the years after his death a great number of religious works of high quality were produced in Brussels.

Address
Lange Vijverberg 14, Den
Haag
✆ 070362 0729

Map reference
⑫

How to get there
In the historic centre

Opening times
Tue to Sun 12–5. Closed
Monday

Entrance fee
G. 6 adults; G. 4 children
and groups

Abraham Bredius was a privately rich scholar who became the controversial director of the Mauritshuis at the end of the nineteenth century. During his turbulent administration many distinguished pictures were acquired, especially works by Rembrandt and Vermeer. Bredius himself collected in his private capacity and his aim was to represent the minor masters, particularly those not thought to be important enough or indeed beautiful enough to grace the walls of his beloved Mauritshuis. Bredius resigned in mid-career, it is said because of scandal in his personal life. He 'retired' to the South of France where he completed his still-quoted book on Rembrandt.

Bredius's collection offers little to the visitor in search of the spectacular or the moving; it is for these qualities that the Mauritshuis is renowned. Yet almost all of his two hundred or so pictures repay quiet contemplation. One comparison will serve: in the Mauritshuis is the elaborate *Flower Piece* by Ambrosius Bosschaert (page 90) and Bredius acquired for himself a work by the same extremely rare master. Bredius's picture is the precise opposite of the work in the Mauritshuis; small in scale and intimate in mood it consists of three tulips in a vase. We cease to marvel at the skill, but we are forced to contemplate the simplicity of the subject.

Bredius did not shy away from the vulgar aspect of some Dutch seventeenth-century painting and there are low life peasant scenes as well as more elegant works. Almost all the Dutch seventeenth-century genres are represented, and there are a few quite unexpected works as well.

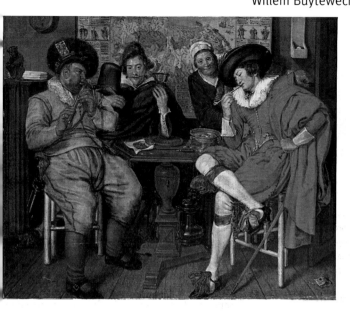

Many people have wondered how and why Dutch painting achieved such an astonishing flowering in the seventeenth century, but few of them look at the works from the earliest years which anticipate the later achievements. Only a handful of pictures by Buytewech (1591/2–1624) survive, and most of these are figures in interiors. Here we have a jolly inn scene painted with a great sense of humour. The main characters are prosperous men rather than the peasants so often shown in the low life inn scenes popular later in the century. By modern standards the man on the left playing the flute is gross, but he forms a well-observed contrast to the young dandy on the right who is enjoying a smoke. Sometimes when people are shown smoking it is not always tobacco, but here it probably is. Such pictures captivate by their lack of artistic inhibition – Buytewech records rather than arranges. This picture forms a complete contrast to the elegant scenes preferred in the 1630s, showing the well-heeled and the well-dressed behaving in a more genteel manner. It is open to question whether the serving woman will be providing favours or whether the idea is to get the callow young man drunk or drugged.

Flowers in a Vase

1669

Simon Verelst

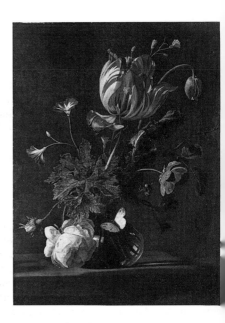

To the uninitiated Dutch flower pieces have a bad habit of looking rather alike, but this work by Simon Verelst (1644–1710 or 1721) represents the exact opposite of the glorious work by Ambrosius Bosschaert the Elder (page 90). In this picture there is a new attempt at simplicity, with the artist showing off his skill not only in the depiction of each flower but in the arrangement. The bones of the composition are Baroque in that the flowers and their stems are arranged in rhythmic lines. The flowers show an attempt at the unity of the seasons, since they all bloom in early summer. They are the late-flowering tulip, the poppy, the damask rose, the convolvulus and the periwinkle. Notoriously vain, Verelst was considered to be one of the most skilled flower painters of his time and from *c.* 1669 onwards he worked in London. His pictures so astonished Samuel Pepys that he wrote of Verelst, 'The finest thing I ever saw in my life, the drops of dew hanging on the leaves, so as I was forced again and again to put my finger to it to feel whether my eyes were deceived or not'. The presence of the butterfly and the autumnal-looking leaf may indicate a *vanitas* element, especially as the tulip has a wilting petal. The picture would then be seen as a reminder of the brevity of the natural order of things, as beauty fades into decay.

Hendrick Willem Mesdag, a leading painter of The Hague School in the nineteenth century, went out of fashion a long time ago. His pleasant landscapes and seascapes are too undemanding and too close to the mores of the late nineteenth-century bourgeoisie who admired his work for present-day tastes.

Mesdag's story as a collector is a rather different one. He collected the work of his rather superior Hague School contemporaries and this museum's collection now forms one of the main groups of this type of art in the Netherlands. Other examples are in the Gemeentemuseum, The Hague, and in the Rijksmuseum, Amsterdam, where they tend to get overlooked owing to competition from the other areas of the collections. The subject matter of most Hague School pictures is generally undemanding, but Mesdag's choice tended towards the grittier end of the spectrum. The unusual aspect of his collecting was his interest in contemporary French painters, although he managed to avoid the work of the Impressionists. To collect the work of Courbet, Corot and Delacroix was unusual outside France in this early period, and it was only in the late nineteenth and early twentieth centuries that these pictures became fashionable with foreign, especially American, collectors.

Mesdag was not guided by any formal criteria with his Corots and Courbets; it seems he bought examples of their work because he liked it, hence the variety of subject matter. He was not attracted to highly finished works, a style in which the Dutch and French academies of the time excelled. There is, for instance, no elaborate Classical scene by his Frisian contemporary and compatriot, Alma-Tadema. The Mesdag collection has been closed for a period of time and it is hoped that this time-capsule of nineteenth-century taste will soon be returned to its rightful place in the splendid group of museums which make up the rich heritage of The Hague.

Address
Laan van Meerdervoort 7, Den Haag
✆ 070 635 450

Map reference
⑬

How to get there
Near Peace Palace

Opening times
Tue to Sat 10–5; Sun and public holidays 1–5. Closed Monday. Temporarily closed at time of publication, so check before visiting. Re-opening in 1996.

Entrance fee
G 7

Reclining Nude

1866

Gustave Courbet

French nineteenth-century realist painting was one of Hendrick Willem Mesdag's preoccupations and he acquired a remarkably broad selection. This splendid Courbet (1819–77) is a less well-known example of the artist's female nudes of the type that earned him notoriety in his lifetime and posthumous fame. Courbet is known as the great realist but his realism seems a little on the artificial side when compared to Dutch realism of the same period. The sleeping figure is 'artistically' arranged on the elaborate four-poster bed and the curtains fall in a consciously boudoir manner in order to enhance the composition. The realism which shocks is reserved for the openly sensual and sexual way the woman's breasts are exposed in the abandonment of sleep. She appears satiated rather than lying there in erotic anticipation. Such openness of approach no longer seems even mildly shocking but in the artist's lifetime it caused outrage, even amongst those who had a taste for realism. Courbet's aggressive personality is well recorded and he set out to irritate his contemporaries, a pose which has earned him the admiration of the radically minded ever since. Courbet was so taken with this composition he repeated it several times.

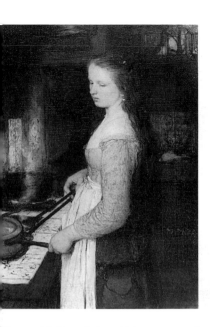

Along with Joseph Israels (see page 116), Matthijs Maris (1839–1917) was one of the leading exponents of The Hague School. Less intense than Israels, he was also more steeped in the Dutch genre tradition which stretched back to the seventeenth century. *The Kitchen Maid* takes up where the seventeenth century left off. It is a careful piece of domestic observation, but with the added sentiment of the period. So much observation of this type was entirely matter-of-fact in the seventeenth century, especially if a single figure was depicted. In this picture there is a quite different observation of character: the artist has managed to convey the feeling that the kitchen maid is thinking of something else while she is at the stove. There is no obvious symbolism to suggest that the girl is lovesick or feels oppressed, she simply appears lost in sad thought. The picture had acquired several different titles by the end of the nineteenth century, including *The Kitchen, The Young Housekeeper, Flemish Kitchen, The Cook* and so on, reflecting the fact that it has no obvious subject. This is testament to its modernity, since the artist has departed from the necessity to tell a specific story, leaving the spectator to make the judgement. In this respect Maris deserves a higher position than his current reputation suggests.

Alone in the World

c.1880

Joseph Israels

This haunting picture was famous in the pre-World War One period and then, along with the rest of the artist's work, went completely out of fashion. It is on the borderline between realism and sentiment. An old couple, after a long life together, are parted by death. The man sits in silent despair rather than visible anguish, awaiting his own fate. The painting is unusual for Israels as most of his other work consists of innocuous genre pieces and a few portraits, including one of Mesdag himself. The technique used by Israels, and some of his other contemporaries in The Hague School, was self-conscious. The smooth surfaces and carefully observed detail of the Dutch tradition which had survived from the seventeenth century was abandoned in favour of a much freer approach. Rather too much emphasis has been made of the influence of French realists such as Courbet. The stylistic source is much older than that, coming much more from early nineteenth-century Scottish artists such as David Wilkie, and Israels' style can be paralleled in his Scottish near-contemporary William Quiller Orchardson. The technique was to keep the paint thin and the touch light, while the colour range was made as narrow as possible. This has the effect of increasing the intensity of the picture's theme.

There are many small museums in the major Dutch cities, and this one is the Dutch equivalent of an English country house collection, with its remarkable series of family portraits belonging to the Meerman and Westreenen families, supplemented with some other quite unrelated works.

The Meerman group is richest in late sixteenth- and early seventeenth-century portraits recalling the larger English collections such as those of Hardwick Hall in Derbyshire. The exception here is the exquisite portrait of Gerard Meerman by the French eighteenth-century artist Jean-Baptiste Perroneau. Many of these portraits, just as in English collections, are by anonymous artists but are often of high quality. The most delightful is the child portrait of Catherina van Warmondt of 1596 by Isaac Claesz. van Swanenburg, whose son Jacob Isaacz. van Swanenburg was Rembrandt's first teacher in Leiden.

The Westreenen family portraits are largely eighteenth-century in origin with some striking ones by Guillaume de Spinny. The unexpected part of the collection is the small group of fourteenth- and early fifteenth-century Italian panel paintings which includes two small complete triptychs, one from the school of Sassetta (d.1439) and the other close to Nardo di Cione (d. 1366). Even though this collection has no masterpieces it deserves a visit from those interested in Dutch family history and collecting. The museum also has over 300 manuscripts, many of which date from the late Middle Ages and contain superb illuminations. Among the collection of early books are incunabula and important examples of early printing.

Address
Prinsessegracht 30, Den Haag
℡ 070 346 2700

Map reference
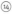

How to get there
Just to the east of the old centre

Opening times
Mon to Sat 1–5; closed Sun and holidays

Entrance fee
G. 3.50

Virgin and Child Enthroned with Saints

C.1370

Francesco di Vannuccio

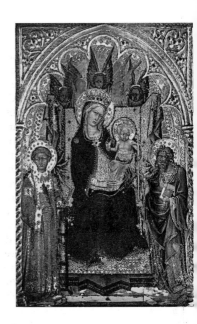

This small devotional picture, which is only just over thirty centimetres high, has only recently been attributed to the Sienese master Francesco di Vannuccio (c. 1315/6–still working 1376), from whose hand only one signed work has come down to us, *The Virgin and Child* in Berlin. In its extensive use of delicately tooled gold leaf and its carved and gilded frame the picture is typical of Sienese art of the fourteenth century, which placed a strong emphasis on the quality of decoration. The linear draperies, especially of the figure of St. Andrew on the right, are drawn with more emphasis on ornament than realism. The strong reds and deep blues combining with the gold leaf give the picture an intended glowing richness. On this small scale it would have been used for devotional purposes rather than adorning an altar. Even though Francesco di Vannuccio was a follower of the much greater Sienese painter Simone Martini it would be unfair simply to classify him as inferior. The angels surrounding the Virgin's head have a quirky intensity in their expressions and their wings are arranged in an exquisitely decorative way; this contrasts with the hieratic serenity of the Virgin's face. The whole has an amazing dignity given its small scale.

In spite of its ancient atmosphere, the Schilderijenzaal Prins Willem V is a creation of modern museology. Started in the 1970s, the idea was to reconstruct a gallery of Old Masters as it would have appeared in the eighteenth century; not a single collection had survived from this period in the entire Netherlands. Such a notion might seem curious to most other European countries as so many of their historic collections are preserved on the walls of their royal palaces and country house museums. Not so for the Dutch, because not only was there a mania for selling things but also a good number of Prins Willem's pictures, looted from the Mauritshuis by the French, were never returned and now grace the walls of French museums. The method used to bring this entirely convincing gallery together was a complicated one. The reserves of the Mauritshuis were combed, the Rijksmuseum in Amsterdam was persuaded to lend duplicates, and the State Office of Moveable Monuments (responsible for pictures) returned pictures from long-term loan from museums all over the country and even distant embassies. The effect is convincing and the mood of an eighteenth-century collection successfully created. Even the nearby Mauritshuis owes a good deal of its present appearance to nineteenth and twentieth century collecting, starting with that most enthusiastic of Dutch kings, Willem I.

The gallery is one long, narrow space decorated in the eighteenth century with an elaborate Rococo ceiling and walls hung floor to ceiling in the eighteenth-century manner. Recently, however, there have been a number of changes and some precious pictures have been returned to their lenders or reallocated elsewhere.

Address
Buitenhof 35, Den Haag
✆ 070 318 2487

Map reference

How to get there
On the other side of the Vijver from the Mauritshuis

Opening times
Tue to Sun 11–4. Closed Monday

Entrance fee
G. 2.50 adults; G. 1 children and seniors over 65

The Bear Hunt

1649

Paulus Potter

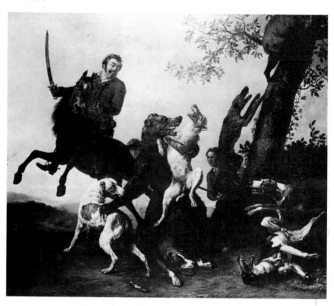

Hunting scenes were a popular genre in the seventeenth century, and this is one of the most spectacular. It forms a dramatic contrast to Potter's (1625–54) other masterpiece, *The Young Bull* in the Mauritshuis (page 98). The artist's sensitivity to the animal kingdom was unusual enough in its time but here the scene of violence is taken to an unexpected extreme. The pack of hounds has attacked two bears, and one of them has sought the refuge of a tree and is pursued by a hound which cannot climb so well. The beleaguered bear in the centre of the composition is putting up a good fight. One hound is gripped to suffocation point, another is in pain under the bear's hind quarters and a third tries to bite the bear's leg in retaliation. The real horror, however, is reserved for the hound on the right howling in agony on its back; its leg has been bitten off at the knee and lies in the centre foreground. The grimacing hunter himself seems shocked by the carnage and it is difficult to escape the feeling that Potter had some message to convey. The Baroque nature of the composition is unusual for the artist and shows the influence of the Flemish School, especially the work of Rubens and Frans Snyders who between them painted a number of large-scale hunting scenes, although they never achieved the realistic violence of this one.

Leiden is a picturesque city – ancient, quiet, and in most people's minds something of a backwater. The Museum 'De Lakenhal' – the cloth hall – sits unassumingly by the side of a canal. Its seventeenth-century facade appears somewhat on the provincial side after the classic perfection in miniature of the Mauritshuis, The Hague. Inside the proportions of the interiors, especially those on the first floor, have kept their seventeenth-century form and early decoration. These rooms are historical in their arrangement and there are seemingly endless portraits of Leiden worthies, especially of the eighteenth and nineteenth centuries. The Dutch liked to make portrait collections and there is another extensive one in the University.

The distinguished Leiden painters of the seventeenth century have only a token representation, and in most instances these are in pictures of specialist interest acquired in recent years; this even applies to the single work by Rembrandt (page 124). The real reason for the visit to Leiden is the single room of sixteenth-century paintings whose centrepiece is the huge triptych by Lucas van Leyden (page 123). The museum also owns an exceptionally beautiful portrait drawing by the artist, but this is not normally on view. The other significant pictures flanking the Van Leyden are all by the Leiden artist Cornelis Engebrechtsz. and their importance, apart from their distinction as works of art, is the fact that they have survived at all.

There are also pleasant and instructive examples of the decorative arts, seventeenth- and eighteenth-century furniture, Delftware, tiles and numerous artefacts, and these lend an agreeable atmosphere to what otherwise might be rather hard on the visitor's powers of concentration.

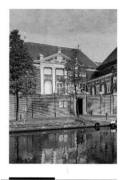

Address
Oude Singel 28-32, Leiden
 071 120820 (recorded information)

Map reference
(16)

How to get there
Close to the railway station

Opening times
Tue to Fri 10–5; Sat, Sun and public holidays 12–5. Closed Monday

Entrance fee
G. 5 adults; G. 3 children 6–18

Crucifixion Altarpiece

C.1520

Cornelis Engebrechtsz.

In the mid sixteenth century, The Reformation and the iconoclastic crisis which formed part of it, swept away almost all the religious paintings from Dutch churches, and even private collections lost their treasures. This explains the extreme rarity of any religious art in the northern Netherlands from the years prior to 1570. This intense picture, along with another work by Engebrechtsz. (1468–1533), is an especially precious survival. Engebrechtsz. represents the end of the late Gothic tradition in the northern part of the Netherlands which was so much more backward than the richer cities of the south, such as Bruges and Ghent. The artist's detailed arrangement of so many figures is reminiscent of the sculpted wooden altarpieces which were very popular at the time, some of which survive scattered in many different museums. This altarpiece is especially complete, as not only has it kept both its painted shutters but also the narrow predella underneath the central panel. The subject of this is most unusual because it shows the Tree of Life growing out of the corpse of Adam. Engebrechtsz. favoured twisted poses for his figures and he used intense bright colour. It was this boldness which he transferred to his brilliant pupil, Lucas van Leyden (see page 123).

This famous altarpiece was considered so exceptional in its time that it was spared destruction by the iconoclasts. It is consequently the only large-scale work by the artist to survive. The reverse sides of the shutters contain single figures of saints which are especially well drawn. The picture is the last in the series of great Flemish Last Judgement altarpieces, the best known being those by Rogier van der Weyden (Beaune, Hôpital) and Hans Memlinc (Gdansk).

Lucas van Leyden (c.1494–1533) abandoned the rigid arrangement of the usual fifteenth-century format for a much looser approach. The effect is one of violent movement across the whole of the lower half of the picture. God, who usually presides in such grave splendour, is reduced to an insignificant figure in the vast expanse of sky. The focus of the centre panel shows the human race rising from the dead, naked and exposed. In the drawing of the figures it is easy to see how the artist had learned from the example of the Italian Renaissance which placed an emphasis on drawing as much as colour. The whole picture lacks the polish of all the earlier altarpieces and the artist even allowed the drawing to show through the draperies, which were painted in semi-transparent colour. This gives a strong feeling of light and movement which contrasts with the spiky intensity of Cornelis Engebrechtsz., the artist's master.

Unidentified Mythological Scene

1626

Rembrandt van Rijn

Painted when Rembrandt (1606–69) was only twenty years old, the subject of this restless picture has eluded all scholarly enquiry. It was only rediscovered in the 1920s and its appearance changed the conventional view of Rembrandt's earliest years in Leiden, when he was still under the spell of obscure local painters.

The composition is rather confused with so many figures jostling together. The subject of a potentate holding his sceptre is from either history or mythology. One of the surprises for those who are familiar with Rembrandt's mature work is the disconcertingly high-key colour with bright red draperies of the saturated intensity seen in later pictures. The small head in the background just to the right of the main figure is that of Rembrandt himself. He occasionally introduced himself into his subject pictures, rather more spectacularly at the foot of the Cross in one of his *Passion* series painted for the Stadhouder. This modest image must be taken as the first in the long series of self-portraits. It is hardly likely that such pictures were successful and Rembrandt soon changed his scale, format and style, a development which culminated in his *Jeremiah Lamenting the Destruction of Jerusalem* (page 44), painted only four years later.

The author and publisher would like to thank the following museums and galleries, individuals and photographic archives for their kind permission to use the following illustrations:

A.F.Kersting, London: 6, 15, 18, 22, 24, 56, 60, 61, 73, 79, 81, 83, 86, 110, 113, 117, 119, 121

Amsterdams Historisch Museum: 7a, 14, 16, 19, 20, 21

Rijksmuseum, Amsterdam: 7b, 9, 10al&ar, 10b, 11a&b, 12a&b, 13l&r, 25, 26, 27, 28, 29, 30, 31, 32, 33, 34, 35, 36, 37, 38, 39, 40, 41, 42l&r, 43, 44, 45, 46, 47, 48, 49, 50, 51, 52, 53, 54, 55

Museum het Rembrandthuis, Amsterdam: 23

Vincent van Gogh Foundation, Van Gogh Museum, Amsterdam: 57, 58, 59

Stedelijk Museum, Amsterdam: 62 (© DACS 1995), 63, 64, 65 (© ADAGP, Paris and DACS, London 1995), 66 (© Tulp Pers), 67, 68 (© ADAGP, Paris and DACS, London 1995), 69, 70, 71 (© 1995 ABC/Mondrian Estate/Holtzman Trust. Licensed by ILP), 72 (© ADAGP, Paris and DACS, London 1995)

Frans Hals Museum, Haarlem: 74, 76, 77a&b, 78

Mauritshuis/RBK on loan to the Frans Hals Museum: 75

Teylers Museum, Haarlem: 80

Haags Historisch Museum: 82

Haags Gemeentemuseum, The Hague: 84a&b (© 1995 ABC/Mondrian Estate/Holtzman Trust. Licensed by ILP), 85

Mauritshuis, The Hague: 87, 88, 90, 91, 92, 93, 94, 95, 96, 97, 98, 99, 100, 101, 102, 103, 104, 105, 106, 107, 108, 109

Museum Bredius, The Hague: 111, 112

Mesdag Museum, The Hague: 114, 115, 116

Rijksmuseum Meermanno-Westreenianum, The Hague: 118

Schilderijenzaal Prins Willem V, The Hague (Mauritshuis): 120

Stedelijk Museum ' De Lakenhal', Leiden: 122, 123, 124

The author would like to dedicate this book to Bob, who loved Amsterdam.

INDEX

Index of Artists, Sculptors and Architects
Figures in bold refer to main entries

The following itineraries each cover half a day and the fourteen itineraries build up to a full week's sightseeing at a fairly leisurely pace. Those with only a few hours at their disposal should concentrate on the starred items. Works of art are listed in alphabetical order according to artist, as Dutch museums change their displays too often for a specific itinerary to be suggested. The information desk at museums such as the Rijksmuseum should give the current locations of paintings.

The numbers in circles beside each location are map references. Most museums are open every day except Mondays and even on public holidays, apart from 1 January. Churches have not been given individual entries as they are too frequently closed, although they often form a significant part of the townscape, especially at Haarlem.

Although many trams in Amsterdam pass the Rijksmuseum, the best way round the entire centre is on foot. The Frans Hals Museum in Haarlem can only be reached on foot and all the museums in the Hague except the Gemeentemuseum and the Museum Mesdag are in the small historic centre. Because of the vast size of the Rijksmuseum and the relative smallness of the other collections it is suggested that the visitor make two visits, first to see the Dutch seventeenth-century collection and second to concentrate on the earlier fifteenth- and sixteenth-century Netherlandish paintings and the foreign, especially Italian pictures. At the time of writing the eighteenth- and nineteenth-century sections were closed, but they are expected to reopen in the future. The prices and opening times of all museums are correct at the time of publication but may be liable to change without notice.

DAY 1 MORNING

✪ **AMSTERDAM, RIJKSMUSEUM** ③ (p.24)
Closed Monday

The Threatened Swan
Jan Asselijn (p.25)
Helena van der Schalke
Gerard ter Borch (p.26)
The Home Fleet Saluting the State Barge
Jan van de Cappelle (p.27)
✪ **Rembrandt's Mother Reading**
Gerrit Dou (p.28)
Landscape with Two Oaks
Jan van Goyen (p.31)
✪ **The Merry Drinker**
Frans Hals (p.32)
✪ **The Celebration of the Peace of Munster**
Bartholomeus van der Helst (p.34)
Women and Child in a Pantry
Pieter de Hooch (p.35)
✪ **Three Women and a Man in a Courtyard Behind a House**
Pieter de Hooch (p.36)
Old Women in Prayer (Prayer Without End)
Nicholas Maes (p.37)

The Sick Child
Gabriel Metsu (p.38)
The Fishwife
Adriaen van Ostade (p.40)
Jeremiah Lamenting the Destruction of Jerusalem
Rembrandt van Rijn (p.44)
✪ **The Militia Company of Captain Frans Banning Cocq and Lieutenant Willem van Ruytenburch (The Night Watch)**
Rembrandt van Rijn (p.45)
The Syndics: the Sampling Officials of the Amsterdam Draper's Guild
Rembrandt van Rijn (p.46)
✪ **A Couple: The Jewish Bride**
Rembrandt van Rijn (p.47)
The Windmill at Wijk bij Duurstede
Jacob van Ruisdael (p.48)
Interior of the Mariakerk, Utrecht
Pieter Jansz. Saenredam (p.49)
The Merry Family
Jan Steen (p.50)
The Harbour at Middelburg
Adriaen van der Venne (p.51)
The Little Street
Jan Vermeer (p.52)
The Maidservant Pouring Milk
Jan Vermeer (p.53)